LEGENDARY LOCALS
— OF —

WEYMOUTH
MASSACHUSETTS

LOWER PLANTATION OF WEYMOUTH, 1750.

Lower Plantation
In 1622, Thomas Weston, a London merchant, established a plantation in North Weymouth known as Old Spain. Located on fertile soil along the shoreline, Weymouth was primarily a fishing and agricultural community. This map of the "Lower Plantation" shows the landowners of 1750. The original boundaries of the town remain unchanged today. (Courtesy of Debbie Sargent-Sullivan.)

Page 1: This photograph of the Weymouth Town Hall was taken by Francis E. Whipple. From 1938 to 1941, he was a photographer for *Flair*, an illustrated magazine of the South Shore published in Weymouth. He was also a printer, introducing printing to the Weymouth Vocational Technical School. Francis later became assistant superintendent of Weymouth Schools, retiring in 1967. (Courtesy of F.E. Whipple.)

LEGENDARY LOCALS
OF
WEYMOUTH
MASSACHUSETTS

DEBBIE SARGENT SULLIVAN
AND ERICA JILL DUMONT

LEGENDARY LOCALS

Copyright © 2013 by Debbie Sargent Sullivan and Erica Jill Dumont
ISBN 978-1-4671-0034-2

Legendary Locals is an imprint of Arcadia Publishing
Charleston, South Carolina

Printed in the United States of America

Library of Congress Control Number: 2012938375

For all general information, please contact Arcadia Publishing:
Telephone 843-853-2070
Fax 843-853-0044
E-mail sales@arcadiapublishing.com
For customer service and orders:
Toll-Free 1-888-313-2665

Visit us on the Internet at www.arcadiapublishing.com

This book is dedicated to the founders and members of the Weymouth Historical Society for their forethought and vision in preserving the history of the town.

On the Cover: From left to right:
(TOP ROW) Harry Arlanson, football coach (courtesy of Carl Arlanson; see page 119); Salvatore Pardo, cobbler (courtesy of Linda Pardo; see page 86); James D. Asher, broadcaster (courtesy of James D. Asher Jr.; see page 60) Cecil Evans, harbormaster (courtesy of Katherine Sellers Cleveland; see page 34); Zachariah Bicknell, politician (courtesy of Donald Cormack; see page 79);
(MIDDLE ROW) Hal Holbrook, actor (courtesy of Jane Holbrook Jewell; page 63); Appleton Howe, doctor, (courtesy of Tufts Library; see page 23); Don and Eleanor Cormack, historians (courtesy of Jean Cormack King; see page 36); Dan Howley, baseball coach (courtesy of Donald Cormack; see page 116); Don Kent, weatherman (courtesy of Margaret Mathewson Kent; see page 59);
(BOTTOM ROW) Tim Sweeney, hockey player (courtesy of Tim Sweeney; see page 124); Mary Quinn, Army nurse (courtesy of Mary Quinn; see page 21); Benjamin Franklin White, banker (courtesy of Tufts Library; page 73); Jane Holbrook Jewell, philanthropist (courtesy of Jane Holbrook Jewell; see page 40); William Seach, sailor (courtesy of Stephen King Donovan; see page 13).

CONTENTS

Acknowledgments 6

Introduction 7

CHAPTER ONE Municipal Servants 9

CHAPTER TWO Civil Servants 31

CHAPTER THREE Unforgettable People 49

CHAPTER FOUR Industrialists 67

CHAPTER FIVE Athletes 113

Index 126

ACKNOWLEDGMENTS

Throughout this journey, we have been fortunate enough to have the help and guidance of so many people, without whom *Legendary Locals of Weymouth* would not have been possible. We would like to say a special thank-you to the following people: Brenda Sargent Adams, Carl Arlanson, Amanda Blake, Stephen Blake, Elizabeth Cicchese, Roger Cicchese, William Cicchese, Katherine Sellers Cleveland, John R. Coffey Jr., Marion Colasanti, Velma Collyer, Rob Cronin, Michael Crowley, Jeffrey Cummings, Beverly Demorat, Paula Plett Dimattio, Stephen King Donovan, Diane Dumont, Eileen Ellis Dumont, Rick Dumont, Jacki Earp, Linda Colasanti Federico, George Ghiorse, Ruth Ghiorse, Marjorie Hunt Giannone, Julie Gonzalez, Cindy Gourgue, Barbara Johnson, Robert Johnson, Dan Kelleher, George Lane, Katie McDonald, Robert McLean, Paula C. Mine, Katie Mulligan, Elizabeth Sheppard Murphy, James Palmieri, Linda Pardo, Al Perette, Marilyn Perette, Sharon Orcutt Peters, Malcolm Pohl, Lynn Porter, Aaron Range, Mary Curran Riley, Marcia Sargent, William F. Sargent, Joe Striano, Megan Sullivan, and Ed Walker.

INTRODUCTION

Cohasset for beauty,
Hingham for pride,
If not for its herring,
Weymouth had died.

Weymouth was established in 1622 as the second town of Massachusetts after Plymouth. It was comprised of a group of Englishmen, all here to start a new life in a place where the soil was fertile and plentiful and the water routes to Boston were simple and direct. They quickly established an agricultural community but did not remain that way for long. Weymouth became home to physicians, clergymen, shopkeepers, and laborers. The men of Weymouth always answered the call to arms when their country needed them and continue that tradition today.

As the Industrial Revolution gripped America and the entire Western world, Weymouth felt the tides turn as well. By the middle of the 19th century, Weymouth was a booming business town. The shoe industry was Weymouth's key economic lifeline, and it seemed that there was a factory on every corner. Dizer, Stetson, and Clapp were only three of the many companies that employed hundreds of Weymouth workers. The shoe-manufacturing industry in Weymouth was prevalent for about 100 years. Even until the mid-1970s, when the Stetson Shoe Company closed down, there were shoemakers in Weymouth.

At the beginning of the 20th century, Weymouth continued to evolve. The trolley tracks that had lined the streets for years were being replaced by better roads in order to accommodate the increasing number of automobiles in town. The large amount of forested area was beginning to be removed, as Boston's population increased and families moved south of the city. When the United States went to war in the 1940s, Weymouth became a military focus. The South Weymouth Naval Air Station was one of the leading bases in the country. Men and women from all over the country moved to Weymouth to live on the base, and many stayed in town after the war ended. During the late 1940s and 1950s, Weymouth grew at a quick pace as military men came home to start a family and make a life for themselves. While the people and businesses of Weymouth developed, so did the community. Over time, clubs, associations, societies, groups, and the like were formed, the schools improved, the churches expanded, and the town as a whole became a symbol of American ingenuity, productivity, and progression.

Weymouth has come a long way since the first European settlers arrived in 1622 and is continuing to grow, change, and develop every day. Weymouth owes its incredible history to the people who have helped shape its future and form its character; these are the legendary locals who should be celebrated for their courage, dedication, and vitality.

CHAPTER ONE

Municipal Servants

Because of Weymouth's long history, the town and its people have had quite some time to show their strength via military, police, and fire personnel. Weymouth has had its fair share of heroes who have risked and given all both on the battlefield in distant lands and at home protecting those they cherish. The town has sent soldiers to every war that the colonies and the United States have fought in and is credited with five Medal of Honor recipients. There are four fire stations in Weymouth employing about 100 firefighters, and the town boasts a large and respected police department. In addition, Weymouth was home (along with Abington and Rockland) to the South Weymouth Naval Air Station, which served New England and America from 1940 to 1996. The following chapter highlights the many brave men and women of Weymouth who have dedicated their lives to service in the United States military, the Weymouth Police Department, and the Weymouth Fire Department.

Zerah Watkins Torrey
Zerah Torrey was a military man through and through. He graduated from West Point in 1880 and was promoted to second lieutenant in the 6th Infantry. Following his graduation, he served at White River, Colorado, and then at Fort Cameron, Fort Douglass, and Thornburg, Utah. He moved up in the ranks and became regimental quartermaster in 1890, captain, and ultimately major of the 24th US Infantry in 1901. During the advance on Santiago, he displayed bravery and courage despite being wounded in the leg. Torrey is buried in Arlington National Cemetery. (Courtesy of Weymouth Historical Society.)

Pvt. William A. Torrey
Private Torrey was a baseball star in the 1860s. Back then, baseball was becoming very popular in the United States, particularly in New England. Local teams played against each other for crowds of hundreds. Professionally, Torrey was a boot maker like many other Weymouth men when he enlisted in the US Army on November 12, 1872. He stood a little over five feet four inches, every inch of him a patriot. Along with his comrades of Company E, 7th US Cavalry, he made the ultimate sacrifice during the battle of Little Big Horn. His company fought with Custer's column, and none of them made it home alive. Twenty-six-year-old Torrey was buried at the top of Last Stand Hill along with all the others who fought with him. He is memorialized by a flagpole that stands in his honor at Weymouth Historical Society's Holbrook Homestead (pictured on page 24). (Courtesy of Debbie Sargent-Sullivan.)

William Seach

Over time, the name William Seach has become synonymous with Weymouth's heroes. There is a school named after him, sure, but his life and military service are why this Weymouth man should be remembered. He was born in London in 1877 and signed on to a merchant ship when he was 15. After landing in Canada, Seach moved to the United States and enlisted in the Navy. He served in the Spanish-American War, but it was his actions in the Boxer Rebellion that earned him military honors. After fighting in several harsh battles against enemy forces, he was awarded the Medal of Honor by Pres. William McKinley. Though he had received the Medal of Honor, Seach was not about to stop. During World War I, he and his comrades were torpedoed by a German U-Boat when they were aboard the USS *Lincoln*. Seach directed the rescue mission, ensuring that his men were safe. When World War I ended, Seach retired to civilian life. Living on Washington Street with his wife, Caroline, he made his living as the owner of a gas station, known as Seach Replenishary. Seach lived a remarkable life and died in 1978 at the age of 101. He was a model citizen and seaman who had given so much of himself for his town and country. His legacy will be forever interwoven in Weymouth's history. (Courtesy of Stephen King Donovan.)

Butch Hunt

George "Butch" Hunt was born in Weymouth and graduated from Weymouth High School as the president of the class of 1935. He knew he wanted to become a firefighter ever since he was a child, and that is exactly what he did. He was one of eight Hunt men who were firefighters, including his father and grandfather. His grandfather John Quincy Hunt was Weymouth's first permanent fire chief and died in the line of duty (see pages 16 and 17). Butch served in the Broad Street station for 43 years, during which time he saved several lives. One night when he and his wife were leaving a theater in Boston, they smelled a strong smell of smoke. Butch went to see if he could help and found a raging fire engulfing the Cocoanut Grove nightclub. He quickly went to work with the other firefighters although he was not on duty but did what he could to help. He retired in 1980 but continued to give back by volunteering at the Shriner's Burn Institute, giving lectures about firefighting and fire prevention, and driving a school bus. Hunt passed away in 1995 after living a life dedicated to doing good things for those around him. He will forever hold a place in the hearts of the firefighters and residents of Weymouth. (Courtesy of Marjorie Hunt Giannone.)

(OPPOSITE PAGE): Hunt is pictured leading the way to the corner of Evans and Pearl Streets, which the town was naming in honor of him. (Courtesy of Marjorie Hunt Giannone.)

Bob —

Hope all is well!

I thought you might enjoy this book on recent Weymouth history which has just come out.

The scary thing about getting old is that you ~~to~~ know or knew almost everybody in the book.

Enjoy —
Bill Salisbury

Bob

Hope all is well.

I thought you might enjoy this book on Famous West Virginia History. Which was just come out.

The coolest thing about Kentucky old is that you get know or knew almost everybody in the book.

Enjoy
Bill Stevens

CHAPTER ONE: MUNICIPAL SERVANTS

John Quincy Hunt
When Chief Hunt walked fearlessly through the smoke into Whitcomb Bakery in lower Jackson Square on October 9, 1929, the blaze had already been squashed under his professional direction. After inspecting an oven for damage, Hunt collapsed. He later died of smoke inhalation and heart problems. John Quincy Hunt was Weymouth's first fire chief. He had been a firefighter for 25 years, serving as district chief for several years, and had been acting as Weymouth chief for five. On that October night, he made the ultimate sacrifice. Along with all of Weymouth's finest who have given their lives in the line of duty, he is honored in the hearts of Weymouth's citizens. Pictured in 1929 from left to right are (first row) John Connor, Fred Webb, and John Quincy Hunt; (second row) Earl Starrett and Don Duval. (Courtesy of Marjorie Hunt Giannone.)

Whitcomb Bakery
George Whitcomb owned the bakery at 887 Broad Street. He made breads, cakes, and pastries with delivery within 10 miles. In 1929, there was a tragic fire in this building that killed John Quincy Hunt. Later, William Crane bought the building and sold soft drinks. By 1938, he had a license to sell beer and opened a barroom. Crane's Café was in business until the 1970s, when it was torn down to make a parking lot. (Courtesy of Virginia Nye.)

Walter Heffernan

Walter Heffernan, pictured sitting at his desk, was the town tax collector in Weymouth for 11 years and acted as police chief at the South Weymouth Naval Air Station for five years. During that time, he was the supervisor for the group of women security guards who guarded the South Weymouth Naval Air Station (see below). Continuing his trend of public safety, he was the director of safety and security for Stop & Shop supermarkets from 1948 to 1967. Heffernan was also a member of the Weymouth Rotary Club, and his hobbies included ham radio and photography. (Courtesy of William F. Sargent.)

Weymouth Naval Air Station Women Security Guards

When the United States went to war in 1941, thousands of young men left to fight. At home, the women were left to take over. All over the country, women were stepping up to the plate, doing jobs that were normally held by men, even security and military-style jobs. One of the first instances of this was in Weymouth at the South Weymouth Naval Air Station. In 1942, several women were hired to work as guards at the main gate of the base. The women, ranging in age from 25 to 38 years, were believed to be the first in the United States to be hired to guard government property. (Courtesy of William F. Sargent.)

CHAPTER ONE: MUNICIPAL SERVANTS

State House Veterans
Weymouth's people have always been ready and willing to give their all when the United States is called to war. Beginning before the American Revolution, Weymouth residents have been right there on the front lines. It should come as no surprise, then, that Weymouth is credited with five Medal of Honor recipients. Every year at the Massachusetts State House, there is a Medal of Honor ceremony during which the Weymouth Veterans Council places a wreath at the Medal of Honor plaques outside of the chamber house. The solemn ceremony is performed every May. From left to right are Jonathan Janik, Rep. James Murphy, World War II Navy veteran Bob Haley, past commander of Ralph Talbot chapter DAV Albert Donovan, Korean War Memorial chairman Fran Tucci, Weymouth veterans agent Frank Burke, and Rep. Ron Mariano. (Courtesy of Francis Burke.)

19

William P. Riley

Officer William Riley lived in Weymouth for 94 years and was known for his eagerness to help and his kind ways. He quickly became friends with everyone he met. He became a Weymouth police officer in 1927 and began a long career of dedicating himself to others. He gained local fame, especially with kids, serving as the town safety officer from the mid-1940s until he retired in 1971. Much of his time went to the Weymouth Police Department, but he was also a public servant in other capacities. During World War II, he served in the Army Air Corps as a military police captain; later in life he served on the staff of the Aquatic School of the American Red Cross and as a first aid instructor. Officer Riley left his mark on Weymouth because of his strong passion for helping fellow citizens and his kind-hearted dedication to doing what was right. He passed away in 2000 at the age of 94. Here, Officer Riley poses with two of his crossing guards, Paul Connolly and Kyle Procter. (Courtesy of Mary Curran Riley.)

Col. Mary C. Quinn
During World War II, the number of Army nurses increased from fewer than 1,000 at the time of the Pearl Harbor attack to about 12,000 only six months later. Mary Quinn became one of these fearless caretakers in 1945 after graduating from Carney Hospital School of Nursing. She served in the Army for over 26 years, living in Germany, Japan, and various places across the United States. She was stationed in Korea from 1951 to 1952 (her MASH unit inspired the hit television show *M*A*S*H*) and then in Vietnam from 1967 to 1968. Mary Quinn displayed courage and strength in caring for the sick and wounded during wartime, an honorable sacrifice that she selflessly made. After retiring in 1976, she and her family moved to Weymouth. Mary kept active in nurses' and veterans' organizations and was the driving force behind the first military nurses' monument erected in Massachusetts. (Courtesy of Col. Mary C. Quinn.)

Robert Frazier

Officer Robert Frazier answered a call to Vine and Broad Streets to help with a disabled car. As he leaned over the tailgate, another car smashed into him, pinning him between the vehicles. Frazier suffered double compound fractures of the femurs and spent 27 months on his back in a body cast. His doctors informed him that he would never walk again. Despite all odds, Robert managed to regain the use of his legs, and went on to drive a tractor trailer, become a hairdresser, and even acquire his pilot's license. He was truly a remarkable individual. (Courtesy of Marion Frazier.)

Bob O'Connor

Whenever there was a problem in town—a pothole, a snowstorm, a flood—Bob O'Connor was the one to call. He was the director of the Department of Public Works and always knew exactly what to do when things went amiss. He began his career at the DPW in 1969, after serving in the Marine Corps for two years. He started as a laborer and then moved up to heavy equipment operator. After that, he became a foreman and a superintendent of what was then called the highway department. In 2002, Mayor David Madden appointed him as the director of the department. He was loyal to Weymouth, having lived in the town his whole life, and worked tirelessly for the town throughout his whole career. In 2011, O'Connor decided he would finally give himself a break, relinquishing his round-the-clock on-duty schedule. Pictured at O'Connor's retirement party, from left to right, are Peter Geaghan, Bob O'Connor, and Steve Santosuosso. (Courtesy of Katie McDonald.)

Dr. Appleton Howe
Born on November 26, 1792, Appleton Howe attended Phillips Academy in Andover and then graduated from Harvard College in 1815. He continued at Harvard, studying medicine with Dr. John C. Warren. When he finished medical school, he was invited to South Weymouth to live among the people and work as the town physician. Howe settled easily into his new town and became very involved in civic affairs as well as in the Old South Church. He served as president of the Norfolk District Medical Society and was a member of the Massachusetts Medical Society. Dr. Howe also served as the surgeon of the 2nd Regiment, 1st Brigade, 2nd Division of the Massachusetts Militia. He died on October 10, 1870. (Courtesy of Tufts Library.)

Weymouth Historical Society

In 1879, the town of Weymouth was already 144 years old and had amassed quite a bit of history and, consequently, objects and documents that represented that history. There was a group of people who believed that the history of the town and its artifacts should be preserved and made accessible to all Weymouth residents. On April 12, 1879, those people formed an organization named the Weymouth Historical Society. From the moment of its inception, the all-volunteer society has been an integral part of the preservation and documentation of Weymouth history and is still in full operation today. The society currently displays its collection in the Weymouth Historical Society Museum located in the basement of the Tufts Library as well as at the historic Jason Holbrook Homestead (pictured) located at 238 Park Avenue in South Weymouth. (Courtesy of Debbie Sargent-Sullivan.)

CHAPTER ONE: MUNICIPAL SERVANTS

Weymouth Historical Society
This photograph, taken in 1897 at House Rock, features early members of the Weymouth Historical Society. From left to right are Martin E. Hawes, Fred C. Bayley, John S.C. Blanchard, Walter L. Bates, Charles H. Bolles, Francis H. Cowing, William H. Clapp, Quincy L. Reed, Rebekah Webb, unidentified, Mrs. W.H. Clapp, Maria L. Pratt, unidentified, John B. Rhines, Helen Rhines, Sir Dominick Colnaghi (British consul), Annie F. Loud, Charles Myrick (T Wharf, Boston), Charles Hallstram (Union Wharf Ice Company), John J. Loud, and William H. Reed. (Courtesy of Tufts Library.)

Prescott Brown

Prescott Brown was an English teacher in the Weymouth schools from 1911 to 1945. The topics he taught, Shakespeare being one of his favorites, were quite serious, although Brown was anything but. He was known for his humor, always telling jokes during class and trying to make the subject interesting. Every year before the Weymouth High School graduation, he would stand up and tell a Latin joke, usually about some ancient philosopher or orator. It would have been terribly unfunny had it not been for Brown's hysterical way of telling stories, his voice high-pitched and a vein in his forehead popping out. He was remembered fondly by his students, who always enjoyed being in his class—a true sign of a good teacher. (Courtesy of Weymouth Historical Society.)

CHAPTER ONE: MUNICIPAL SERVANTS

Caroline Blanchard
When the Tufts Library opened in 1880, Caroline Blanchard was the one chosen for the job of the first librarian. She was born on November 22, 1850, to Nathaniel Blanchard and Susan Hunt Blanchard, who lived on Commercial Street in Weymouth Landing. As a member of the Massachusetts Library Association and the American Library Association, Blanchard attended the group's conferences in 1898, 1900, 1902, and 1906. She worked as Tufts Library's librarian for 28 years until retiring in 1908. During that time, she helped to shape the future of Tufts Library and encouraged reading among Weymouth people. She died in 1917 at the age of 66. (Courtesy of Tufts Library.)

CHAPTER ONE: MUNICIPAL SERVANTS

George William Ventre/Stetson Band
George William Ventre was one of eight boys in his family, all of them musical. He was the leader of the Weymouth Post American Legion Band, which was sponsored by the Stetson Shoe Company. The band consisted of veterans who traveled across the country to perform, mostly in New England and New York. They had become quite popular among their audiences by performing live and on local radio stations, so it was not surprising that when they played at the American Legion Convention in Paris they won several prizes. George (pictured on opposite page) later became the leader of the Oakland-Pontiac Good Will Orchestra. (Courtesy of Carol Seach Donovan.)

Susanna Tufts

On January 1, 1880, a new opportunity was presented to the people of Weymouth when the doors of the Tufts Library opened for the first time. Within the first year, about 5,000 people had become regular borrowers. Delivery stations were set up around town, and everyone had the opportunity to read. This was made possible because of Susannah Tufts and her brother Quincy, who bequeathed money and land to the town of Weymouth for the building of a public library. Over 130 years later, the Tufts Library still serves the town of Weymouth. (Courtesy of Tufts Library.)

Reverend William Hyde

Reverend Hyde was born in Scotland in 1858, but he moved to Weymouth when he was young. He was a religious man who truly practiced what he preached and was known for having a kind heart and a loving soul. He was the rector of Trinity Church in Weymouth from 1885 until 1931 and was very active in all of the various groups related to the church, especially the Sunday School. Besides his religious activity, Reverend Hyde was also a noted historian, serving as treasurer of the Weymouth Historical Society and writing several books on the history of New England. When he died in 1935, he had devoted over half his life to Trinity Church and was greatly missed by family, church members, and friends. (Courtesy of Donald Cormack.)

CHAPTER TWO

Civil Servants

Weymouth citizens have always prided themselves on their willingness to give back to their community and town. Because of their involvement over the years, Weymouth has grown into a vibrant community filled with cultural, recreational, professional, educational, and religious organizations that allow the people of Weymouth to form a unique bond. The following chapter focuses on Weymouth's civil servants: those who have given many hours of their time and effort to make Weymouth a great place to live.

Franklin Pratt

Franklin Pratt was as dedicated as they come. He gave everything he could to Weymouth's Boy Scout Troop 2 and helped the troop accomplish more than anyone thought was possible. Pratt served as scoutmaster from 1938 to 1974 and held the Silver Beaver Distinguished Service Award. During his tenure, he always instilled a sense of obligation to his scouts, showing them that they had a duty to help and serve Weymouth and the rest of the country to the best of their ability. During World War II, Troop 2 showed their dedication. In 1941, they began collecting wastepaper, which earned them $10 per ton. Thirty-four of the Weymouth Troop 2 scouts earned the war service stripe, and the troop itself earned the General Eisenhower Medal for collecting a half ton of waste paper. During the years Franklin Pratt served as Scoutmaster, 97 boys from Troop 2 became Eagle Scouts. It was a record number, indicative of Pratt's dedication. Pratt died in May 1975, but his memory lives on in the Franklin Pratt Library. Located at 1400 Pleasant Street in Weymouth, it was the former location of his home and print shop (below). (Left, courtesy of Weymouth Historical Society; below, courtesy of Edward Walker.)

V. Lesley Hebert

V. Lesley Hebert had always loved trees, and knew that he was destined to work with them. From 1932 to 1946, Les owned Hebert Tree Surgery in Weymouth and was town tree warden for 32 years. He also founded the Southeastern Massachusetts Tree Wardens Association and served as its first president. Aside from working with trees, Hebert had a strong interest in history. He was a member of the Sons of Liberty, the Weymouth Historical Society, and the Abigail Adams Historical Society, and he helped to form the Massachusetts Bicentennial Commission. Every year, he participated in the reenactment of the Battle of Bunker Hill as well as several other reenactments. He died in 1988 at the age of 80. (Courtesy of James Stearns.)

Cecil Evans
Every once in a while, someone comes along who is destined to be remembered forever. Sometimes they are remembered because they were great and powerful—they were famous or they made a lot of money. However, some are remembered simply for being good people, quietly going about their lives doing what is right, just, and good. These people are unsung heroes, and one of Weymouth's was Cecil Evans.

Evans was born in Lynn, Massachusetts, on February 4, 1912. He moved to Weymouth as a young child and graduated from Weymouth High School in 1932. Born with cerebral palsy, he could not walk until much later than most children and had to deal with physical handicaps throughout his life. Once he could walk, it was still a challenge, as he would fall every few steps. However, Cecil was guided by a determination to be someone who would make a difference in the world: giving up was simply not an option.

Living in Weymouth, Cecil grew to love the ocean, and made money as a child by collecting and selling driftwood along Weymouth's beaches. During World War II, he sold boats for a living. In 1947, Cecil Evans finally found his calling when he became Weymouth's harbormaster. In that capacity, he was constantly helping others: for over 20 years he was the one who helped stranded fishermen, assisted lost boats with navigation, and ensured the safety of all boaters in Weymouth's waters.

In September 1948, there was a boat fire at the Wessagusset Yacht Club in North Weymouth. Unfortunately, three of the twelve passengers were killed in the blaze, but the situation could have been much worse had it not been for Evans's quick thinking and willingness to take a risk. He put his own life on the line when he pulled the burning boat away from the pier, where it was a danger to other people and boats. Along with the firefighters who put out the flames, Cecil Evans was praised as a hero that day. But he did not consider himself a hero. To him, it was just part of his job and the right thing to do.

In 1967, at the age of 55, Cecil Evans passed away. He had accomplished a lifetime of helping others and doing what he loved. He overcame the obstacles that were thrown his way and truly made a difference in the world. Cecil Evans was a hero to Weymouth then and is a hero to Weymouth now. He will not be forgotten. (Courtesy of Katherine S. Cleveland.)

Roger Cicchese

A Weymouth resident since 1951, Roger Cicchese is a force to be reckoned with. As a youngster, he had a passion to succeed no matter what came his way. He became a licensed ham radio operator at the age of 12, and after becoming a professional broadcaster at age 17 he did not turn back. While attending Assumption College, he developed and managed an undergraduate radio station. After college and graduate school, he acquired over 25 years of teaching experience, produced over 30 documentaries for radio, recorded 200 songs, and wrote over 500 poems. He also worked tirelessly for the handicapped, raising over $2 million for nonprofit organizations. Amazingly, Cicchese has been totally blind since birth. (Courtesy of Roger Cicchese.)

Loeffler Family

Catherine (Tucker) Loeffler always gave thanks to God for everything she had, especially her 10 children. Her family did not have a lot of money and faced hardships that would make many throw in the towel. But the family had faith. Catherine attended Catholic mass at least every Sunday and raised her children to do the same. The children had a strong desire to make their mother proud. Her daughter Ruth served in the Navy during World War II while Grace was employed as a Snappy Tie Girl (see page 117). All five of their sons became priests, and their daughter Mary became a nun. Finding a family whose sons are all in the same occupation is rare for the 20th century, but to find a family whose sons are all priests is nearly impossible. The Loeffler family is one-of-a-kind and truly a Weymouth treasure. (Courtesy of Ruth Loeffler Schill.)

Canoe Boys

In 1966, five boys were playing near Great Pond in South Weymouth. Paul Garvey, Jeffrey Campbell, Donald Campbell, Daniel Doyle, and Richard McDonald were exploring the bottom of the pond, exposed because of drought, and suddenly found a piece of wood showing through. After some digging, they discovered that the piece of wood was actually part of a boat—an Indian dugout canoe. Historians, anthropologists, and scientists were quick to the scene. After being preserved and carbon-dated, it was discovered that the canoe was built around 1500, prior to European arrival in the area. This important piece of Native American history has been preserved by the Weymouth Historical Commission. It is displayed in the basement of the Tufts Library as part of the Weymouth Historical Society Museum for generations of Weymouth residents to enjoy. (Courtesy of Virginia Nye.)

Don and Eleanor Cormack

Don and Eleanor Cormack had a love and appreciation for history that is rare. Sweethearts at Weymouth High School, the dynamic duo graduated together in 1933. Married for 59 years, they were lifetime members of the Weymouth Historical Society and spent many hours volunteering for the organization, teaching Weymouth's elementary schoolchildren about the history of the town. Don served as president for a number of years and was a strong proponent of the Jason Holbrook Homestead (see page 24) becoming the location of the Weymouth Historical Society. Eleanor passed away in 1998, and Don in 2009. (Courtesy of Jean Cormack King.)

CHAPTER TWO: CIVIL SERVANTS

George Stinson Lord
George Stinson Lord was born in Boston but lived in Weymouth for 56 years. He attended the Teacher's School of Science at Harvard University and was a well-known geologist and historian, writing a myriad of papers on both topics. His scholarly abilities made him a respected figure in the academic community, and he was an undoubted authority on Weymouth history. He worked for Massachusetts Electric Company until he retired at the age of 65 and served as a trustee of the Fairmount Cemetery and a corporator of the East Weymouth Savings Bank. Lord was also a member of the Abigail Adams Historical Society, the Weymouth Historical Society, the Massachusetts Archaeological Society, and the Congregational Church of East Weymouth. (Courtesy of William Bowman.)

James E. Gardner

James Gardner was born in Weymouth in 1955 and was the oldest of five children. Though he was born with only one hand, his outlook on life was limitless. He was an honor student in high school, where he played in the band and graduated in 1973. He studied natural resources at the University of Massachusetts, Amherst, and graduated with his degree in 1977. Gardner was always an outdoorsman, learning to fish and hunt at a very young age, so it was fitting when he was appointed as Weymouth's first park ranger in 1978. He was appointed to Great Esker Park in North Weymouth and was charged with the task of keeping the park and the people who visited it safe from harm. Neighbors saw a decrease in vandalism in the park within weeks of Gardner's appointment. After working for the Town of Weymouth for 10 years, Gardner was hired as an arborist for Narragansett Electric Company in Rhode Island. He died at the young age of 36. His commitment to Weymouth and nature was something that was special, to say the least, and for that James Gardner will always be remembered in his hometown. (Courtesy of Judy Gardner.)

George Lane

When it comes to town politics, few were as active as George Lane (pictured with Dwight D. Eisenhower). He began his public service not as a politician, but as a baseball coach. In 1929, he started the Weymouth Pals, a semiprofessional baseball team that gave people something to feel good about during the Great Depression. His first official position in the political arena was selectman, which he was elected to in 1938. From there, Lane also served as school committeeman, public works commissioner, and assessor. He took a special interest in the children of Weymouth, always lobbying on their behalf. Seeing that kids needed a place to go to stay out of trouble, Lane helped to establish a youth recreation program. Beginning in 1954, he served as chairman of the youth commission for 10 years. Lane was also a pioneer in helping to create classrooms in the Weymouth Public Schools that served special-needs students. Special-needs classrooms later became standard in most schools, but George Lane helped lead the way in Weymouth. After being heavily involved in town politics for almost 50 years, George Lane retired in 1975 and moved to Harwich with his wife. During his retirement, he worked for the Harwich Mariners, reliving his days of Depression-era baseball. Lane passed away in 1993 at the age of 83. The positive change he made during his years of tireless work for Weymouth has left the town a better place in his wake. (Courtesy of George Lane.)

CHAPTER TWO: CIVIL SERVANTS

Wilfred and Donald Mathewson
Wilfred and Donald Mathewson grew up on Bradley Road. The two loved boating, so their father bought a family membership to the Wessagusset Yacht Club, and both boys became senior members as soon as they were old enough. Donald became commodore of the club in 1975 and Wilfred in 1980. Aside from the Wessagusset Yacht Club, both boys were involved in several other town affairs. They both love history. Wilfred has served on the board of directors of the Weymouth Historical Commission and received the Chester Kevitt Award for preserving history. Donald is on the board of the Weymouth Historical Commission, the Weymouth Cemetery Commission, and the Community Preservation Committee. Pictured from left to right are Wilfred Mathewson, Virginia Snowman (sister of Wilfred and Donald and mother to Sally Snowman, pictured on page 62), and Donald Mathewson. (Courtesy of Donald Mathewson.)

Terry Martinson
In June 2012, Terry Martinson celebrated his 40th year of being a minister at the Old South Union Church in Columbian Square. There is hardly a person in the town of Weymouth who does not know who he is. Martinson grew up in New York and graduated with a bachelor's degree from Virginia's Bethany College in 1969. In 1972, he graduated from the Princeton Theological Seminary in New Jersey and was appointed as an assistant minister at Old South Church immediately after. In 1978, he became the senior minister, which is the position he currently holds. Since he began at Old South, Martinson has been involved not only in the church community but also in the community at large. He has been particularly involved with the youth group, which he hosts at the church once a week during the school year. He is a symbol of community togetherness and is beloved of his congregation and his town. (Courtesy of Terry Martinson.)

Jane Holbrook Jewell

Jane Holbrook Jewell descends from Thomas Holbrook, who came to Weymouth in 1635 with Reverend Hull's Company. It is no wonder, then, that she was so committed to the town and its history. When the Jason Holbrook Homestead (see page 24) was taken by eminent domain to build a new high school, the town planned to demolish it. However, Jane Jewell knew that the c. 1763 home was a treasure to her family and Weymouth's history. She and several other concerned citizens worked together to save the house from the wrecking ball.

Because of her efforts, the Jason Holbrook Homestead was moved to the Weymouth Fairgrounds and is now a museum and research library. Jane also maintained four trusts: the William Jason Holbrook and Mary E. Holbrook Scholarship Trusts in the Weymouth School System, the William J. Holbrook Scholarship Trust, the Bill Holbrook arts prizes at Thayer Academy in Braintree, and the Esther J. Holbrook Trust at the Carroll Center for the Blind in Newton. Jane's generous attitude and dedication to Weymouth over the years made her a local treasure. (Courtesy of Jane Holbrook Jewell.)

Cope and Crew

The North Weymouth Cemetery, or Old North, is Weymouth's oldest burial ground, where many of her forefathers were interred. Its 16 acres of rolling hills and terraces are planted with many ancient oak and maple trees, and the property is home to a number of historical figures. When Bill Cope took over as superintendent in 1984, he had a lot of work to do. The old cemetery had been neglected for a number of years, and tall grass and beer cans littered the graves. Through Bill's organizing, and then a year later with the help of his brother Paul Cope, whom he had hired as caretaker, years of bracken and overgrowth were removed. Paul, a mechanic who worked on Bridge Street for 30 years repairing cars, later devoted himself to improving and expanding the cemetery. Through their hard efforts, and with the help of his workers and volunteers, the cemetery has been brought back to a beautiful, peaceful resting place for Weymouth's residents, an oasis where people can take a walk or find a bit of the past. Pictured in front of the chapel, from left to right, are Paul Cope, Jake Curtin, Bill Cope, and Gerry Carven. (Courtesy of Paula M.C. Mine.)

Robert Hunt
Robert Hunt was the owner of Hunt's Store at 750 Broad Street, which his grandfather first opened in 1888. Born in Pittsfield, his family moved to an apartment above the store where they lived until 1947. That year they moved to nearby Cottage Street, where Hunt lived the rest of his life. As a teenager, he was responsible for delivering newspapers from Boston on a rental horse. As an adult, he assumed ownership of the store along with his wife, Dorothy, who he met while traveling to London for the coronation of Elizabeth II. Hunt earned a bachelor's degree in business administration from Northeastern University and a master's degree in business from Boston University. Throughout his life Hunt was involved in several community organizations, including the Weymouth Rotary Club, where he was a member for 50 years. In 1990, Robert Hunt became legally blind, but that did not stop him. He still managed the store every day, using a magnifying glass when necessary. His commitment to the store and the community was truly remarkable. Robert Hunt passed away in 2007 at the age of 83. (Courtesy of Frank Miller.)

Franklin Fryer
When it comes to public service, Frank Fryer is a sterling example. He served in World War II and received the Purple Heart. For most, military service and awards would be enough, but Fryer was not satisfied. When he came home to Weymouth, he continued to serve as a public official, doing whatever he could to improve his town. He was a town meeting member from 1954 to 1999 and was a selectman for 18 years. He became the town clerk in 1976 and served in that capacity for 35 years until he retired in 2011 at the age of 90. Overall, he served the town of Weymouth for 53 years. Pictured in front of 84 Broad Street, from left to right, are Jim Foley, Jack Hart, and Franklin Fryer. (Courtesy of Franklin Fryer.)

CHAPTER TWO: CIVIL SERVANTS

Alma Driscoll

Alma Driscoll was born in 1910 and dedicated her life to education. She became a teacher in the Weymouth Public Schools and quickly became a force to be reckoned with. She is known for making students work hard and not accepting anything less than the best. She always had them memorizing and reciting poems; after all, English was her specialty. Her former students still remember the school days they spent with her and the lessons she taught them. In particular, they remember a clock at the front of the room with a sign that read, "Time passes, but will you?" Throughout her career, she coauthored three books on English that were used by many of her own students. She is now 102 years old and still lives in Weymouth. (Courtesy of Clair Donovan.)

Helen McGovern

Helen McGovern was an Abington native who graduated from Bridgewater Teacher's College (now Bridgewater State University) in 1936. She began her teaching career in Abington but accepted a position at the Athens School in Weymouth in 1945. During her 42-year career in the Weymouth Public Schools, she worked as a teacher, principal, director of instruction, and as the assistant superintendent of schools. As assistant superintendent, she worked tirelessly to establish kindergartens and libraries in all of the Weymouth elementary schools. Helen was a member of the Norfolk County Teachers Association and, after retiring in 1978, a member of the Retired Educators Association of Massachusetts. She died in 2006 at the age of 91. These proud winners of the Weymouth Clean Town Committee trophy are pictured in front of Union Street School (now Thomas W. Hamilton Primary School). From left to right are Dr. Leon Farrin, superintendent of schools; Peg Goudy; Joe Sloan, custodian; Lynn Donahue; Kristin Comeau; Russell Schupp; Brian Fox; Chicky Truett; Helen McGovern, assistant superintendent of schools; and Robert Olsen. (Courtesy of Ralph Sanford.)

CHAPTER TWO: CIVIL SERVANTS

Vincent DiSessa
If you have attended Weymouth High School in the last 55 years or so, you would know Mr. DiSessa. Whether he taught you an important lesson, made you laugh at a joke, or threatened to give you a "knuckle sandwich," Mr. DiSessa is a memorable figure. He enlisted in the Army in 1943, and served during World War II putting his mechanical skills to good use. When the war ended, he decided he wanted to be a teacher, despite being laughed at by his friends. He enrolled at Fitchburg State in 1949 and never looked back. After teaching in North Attleboro for a few years, he moved to Weymouth in 1955 and became a household name. To this day, he is still teaching Weymouth's youth, working as a substitute teacher. Generations of Weymouth High School graduates know and love Mr. DiSessa, and there is not a bad word to be said about him. He is truly a legendary local. (Courtesy of Vincent DiSessa.)

45

Hope Paterson

Hope was born in Milton, Massachusetts, and grew up in Quincy. After graduating from Boston University with a bachelor's degree in sociology, she worked in Providence, Rhode Island, as a social worker for the Red Cross. She later continued her education, earning a master of arts degree in history from Boston University. When she moved to Weymouth with her husband in 1951, she gave her new town her heart and soul. She worked as a substitute teacher and an evening teacher in the Weymouth Public Schools as well as a volunteer museum educator at Weymouth Historical Society's museum. Her volunteer work is what makes her stand out. For years, she served on the board of directors for the Abigail Adams Historical Society, giving tours and enlightening the public on Weymouth's history. Volunteering at Weymouth's libraries as well, she dealt with book donations and book sales. In more recent years, she has volunteered with the historical program at the Church of the Presidents in Quincy. Although much of her volunteered time has gone to historical and educational organizations, Paterson is an accomplished musician. For years, she was actively involved in the Southeastern Philharmonic Orchestra as a violinist. Although she recently moved to Natick, her heart is still in Weymouth. It is because of dedicated and passionate people like her that Weymouth is the great town that it is. (Courtesy of Kenneth Paterson.)

Barbara Johnson

Barbara Johnson was an environmentalist, historian, and volunteer. Whether it was preserving the Back River environment, giving tours at the Weymouth Historical Society Museum, or serving on the Naval Air Base Realignment Committee, Barb always jumped in with both feet. She lived in Weymouth for most of her life and was dedicated to the community. The League of Women Voters, Preservation Committee for the Herring Run, and the Whitman's Pond Association were just a few of the causes she donated her time to. Barbara and her late husband William were both recipients of the Weymouth Citizen of the Year award. Her selfless nature and warm personality made her well-liked by all. Sadly, Barbara passed away in October 2012 at the age of 88. She was truly a gift to the town of Weymouth. (Courtesy of David Van Orden.)

Museum Tour Guides (OPPOSITE PAGE)

The Weymouth Historical Society operates a historical museum in the basement of the Tufts Library in Weymouth. Every year, hundreds of third-graders, Cub Scouts, and various other children's organizations tour the museum, and the volunteers there do a remarkable job. They explain the artwork in the museum, show relevant historical artifacts, and make history come alive for Weymouth's children. Eileen Dumont (left) began volunteering in 2003. She graduated from Weymouth South High School and earned a bachelor of arts degree in education from Emmanuel College in Boston. Her third-grade tours are popular for the exciting museum scavenger hunt and the reading of "The Ox Cart Man" by Donald Hall. Eileen has loved history since she was in elementary school at Ralph Talbot. Michelle Cappellini (right) was one of the senior art students in high school chosen to do a painting for the museum in 1970. The painting of the ship in the picture is her work. Forty years later, Michelle uses her painting as a tool for teaching Weymouth history and art to the children who tour the museum. (Courtesy of Debbie Sargent-Sullivan.)

Susan Kay

Sue Kay grew up in South Boston and attended parochial school. After graduating, she completed a year of business school and became a typesetter and mechanical artist for the *Weymouth News*. She worked for the newspaper for eight years, moving her way up the ladder and eventually becoming the general manager. Her work with the paper got her involved in town politics, and her first appointment was as a member of the finance committee. She went on to serve as chairperson of the appropriations committee, as a member of the board of selectmen, and a member of the Town Meeting. In 2007, Sue Kay was elected the second mayor of Weymouth. Although her political career has been long and successful, Sue Kay is also involved in the community in other ways. For 25 years, she served on the board of directors for Weymouth Youth Soccer, organizing over 2,000 players. Every spring and fall, hundreds of Weymouth children are able to learn the skills and experience the friendly competition of playing soccer on a team as a direct result of the endless dedication of Sue Kay and her comrades. Kay is a mayor and a team player, and it does not get much better than that! (Courtesy of Susan Kay.)

CHAPTER THREE

Unforgettable People

Weymouth is a large town with an exceedingly diverse population of more than 50,000. Although the town has not always been so large, the people have always been quite extraordinary. For over 375 years, Weymouth has given the world all types of notable people: musical, artistic, creative, rich, poor, famous, and infamous. Many of Weymouth's citizens have a colorful story that makes them unique and makes Weymouth shine. The following chapter is dedicated to the unforgettable people from Weymouth who have made an impression on the world by their skill, actions, beliefs, and talents.

LEGENDARY LOCALS

CHAPTER THREE: UNFORGETTABLE PEOPLE

Susan Torrey Merritt

Susan Torrey Merritt was born on June 24, 1826, in South Weymouth. Although she participated in community events and affairs, she was very shy. She never married and was not widely known. However, Susan did leave her mark through artwork. A self-taught artist, she often won prizes at the Weymouth Fair for her work. She is best known for her collage titled "Fourth of July Picnic at Weymouth Landing," which is pictured here. The scene depicts a large outdoor summer picnic at Weston Park, which is behind what is now the Tufts Library on Broad Street. Although she completed several pieces of art in her life, the collage is the only one that has been discovered and the only avenue through which her talent can now be observed. (Courtesy of Debbie Sargent-Sullivan.)

Abigail Adams

Abigail Smith Adams was born on November 11, 1744, in the parsonage of the North Parish Church of Weymouth to the Rev. William Smith and Elizabeth Quincy. She was not formally educated, but was tutored by both of her parents. In 1762, Abigail met John Adams of Braintree, a quick-witted lawyer who became one of America's founding fathers and the second president of the United States. The couple married in 1764, and throughout his long career Abigail was the glue that held their relationship together. Offering him advice and good counsel, she was most famous for reminding him to "remember the ladies." Throughout her adult life, she lived in Boston, Braintree, London, Paris, and Washington, DC. Abigail has the distinction of being the first woman in US history to be the wife of one president and the mother of another. A fearless woman who was ahead of her time, Abigail Adams has earned herself not only a place in Weymouth history but in the history of the nation. (Courtesy of Debbie Sargent Sullivan.)

Joshua Bates

Joshua Bates was born on Commercial Street in Weymouth in 1788. He received his education in Weymouth schools and went on to become a financier, working for the merchant William Gray of Charlestown, Massachusetts. He eventually became a senior partner of Baring Brothers & Co. in London, England. In 1852, he donated $50,000 to found the Boston Public Library and ordered that the city should carry enough books for 100 readers. Later in life, he personally donated 30,000 books to the library. Today, the Boston Public Library is one of the best in the area, with branches all over the city. Bates died in 1864 at the age of 76. (Courtesy of Tufts Library.)

Maria Weston Chapman

Maria Weston Chapman was born in 1806 on Commercial Street in Weymouth. After attending school in England, she returned to Weymouth in 1828 and married Henry Grafton Chapman in 1830. When William Lloyd Garrison began publishing his antislavery newspaper, the *Liberator*, in 1831, the Chapmans became ardent supporters of the movement. Despite ridicule from others, Maria Weston Chapman helped to found the Boston Female Anti-Slavery Society, which called for the abolition of slavery in the nation's capital and the education of Boston's free black population. She was also heavily involved in the Massachusetts Anti-Slavery Society, the New England Non-Resistance Society, and the Weymouth and Braintree Female Emancipation Society until the Emancipation Proclamation went into effect in 1863. Maria Weston Chapman was a fearless leader who inspired people to take action during her time and is still a source of inspiration for those who work for positive change. (Courtesy of Tufts Library.)

Hannah Fifield

Hannah Cranch Bond was the daughter of William Bond, a watchmaker in Boston and the sister of William Cranch Bond, the director of the observatory at Cambridge. She was born and raised in Dorchester but moved to Weymouth in 1814 with her husband, Dr. Noah Fifield. Dr. Fifield was one of the finest and most respected physicians in the area, but Hannah became a public figure in her own right. She became a promoter of the antislavery movement and was good friends with the publisher of the *Liberator*, William Lloyd Garrison, as well as abolitionist attorney Wendell Phillips. She is not nationally known but was a remarkable woman who was fearless in her quest for liberty for all. (Courtesy of Weymouth Historical Society.)

Frances Adlington

Frances Adlington was born in Boston on Christmas Eve, 1789. He was one of 11 children born to Elisha and Amey Adlington. When his father died, he was employed by an English merchant in Boston, but then shortly became apprenticed to Hubbard Oliver to learn the trade of a tailor. In 1812, he married after setting up business for himself. When the War of 1812 began, he quickly enlisted as a volunteer, driven by the inspiring stories he had heard from Revolutionary War veterans. His sons shared his patriotic fervor; all four fought in the Civil War, but only one survived. Adlington moved to Weymouth when his wife died in 1821. He married his second wife a few years later, and both lived the rest of their lives in Weymouth. Adlington became quite an accomplished poet, composer, and author. He wrote hymns for various town events and parties and was active in the antislavery and temperance movements. He died in Weymouth on Palm Sunday, April 6, 1884. (Courtesy of Ruth Wheeler.)

CHAPTER THREE: UNFORGETTABLE PEOPLE

Edmund Aubrey Hunt
Edmund Aubrey Hunt was born in Weymouth in 1855 to Edmund Soper Hunt, who owned a fireworks factory in town. After graduating from Weymouth schools, he worked at an architectural firm in Boston before leaving for Paris to study art at the age of 17. He eventually had a studio in Blackheath, London, but also painted in Italy, France, Belgium, Morocco, and Holland. He was an impressionist painter whose work was shown at the Royal Academy and the Paris Salon. This painting of his brother Frederick is dated 1903 and is in the collection of the Tufts Library in Weymouth. (Courtesy of Tufts Library.)

Davis Bates Clapp

The Davis Bates Clapp Memorial Building has been a prominent feature of Weymouth for almost a century. It was a YMCA for years and then was used as a place of worship by several churches. Many people do not know the history of the building. In 1901, Edwin Clapp was one of Weymouth's shoe manufacturing giants who owned a large factory on Charles Street in Weymouth. His only son, Davis Bates Clapp, had just been admitted as a partner in the business. However, in September of that year, Davis passed away at the age of 23. Edwin was devastated at the loss but decided to honor his young son by constructing the Davis Bates Clapp Memorial Building. Davis was an accomplished athlete, so Edwin designed the building as an athletic complex with an indoor track and adjoining playing fields. The building was used as an athletic complex until the 1980s, when the Clapp YMCA merged with the Quincy YMCA. (Courtesy of Virginia Nye.)

CHAPTER THREE: UNFORGETTABLE PEOPLE

John Ghiorse

John Thaxter Ghiorse, the son of John A. and Charlotte A. Ghiorse, graduated from Weymouth High School in 1928. He attended Harvard University, graduating in 1932 at age 20, with a degree in biochemistry. While at Harvard, he also studied languages and played trombone in the Harvard Band. He was married to Ruth Winkler Ghiorse for over 60 years and was the father of nine children. In 1960, he returned to Harvard as a teaching fellow and earned a master's degree in education. In the early 1930s, he began a nearly 50-year teaching career in the Weymouth Public Schools and became a beloved educator for several generations of Weymouth students. He was deeply interested in science and, in the second half of his career, primarily taught physics. Fascinated with aircraft and flight, he organized model airplane clubs during the late 1930s and World War II. In 1953, he won a national essay contest with a paper on the history of the Wright brothers in recognition of the 50th anniversary of Kitty Hawk. John served as chair of the science department for the last 20 years of his career, providing mentoring and inspiration for the many teachers who worked under his guidance. Shortly before he retired in 1980, he was named Massachusetts Science Teacher of the Year in recognition of his years of service as a science educator. He was also voted into the Weymouth High School Hall of Fame and Weymouth High School Athletic Hall of Fame. As an avid photographer, John also contributed his skills and enthusiasm to Weymouth High's athletic teams, providing coverage for the *Patriot Ledger* and pictures for the yearbooks. He pioneered the filming of football games during the glory years of Harry Arlanson and Jack Fisher. Given John's many talents and contributions as a science educator and athletic activist, he may be best known as the composer of two of Weymouth High's legendary songs: its alma mater, "Cross of Gray," and football fight song, "Fight Maroon and Gold." Pictured are (first row) John T., Ruth A. (John's wife), Seth, John A. (John's father), Charlotte A. (John's mother), Richard, and Marie K. (John's sister); (second row) Elizabeth, Lois, William, John T. Jr., George, Marilyn, and Peter. (Courtesy of George Ghiorse.)

Billy Hill

Billy Hill was born on West Street in Weymouth in 1899. Growing up, he studied violin at the New England Conservatory of Music and played with the Boston Symphony Orchestra. After leaving home at 17 and doing odd jobs to make a living, he finally moved to New York in 1930 to seek success. He found it in 1933 when his song "The Last Roundup" became a hit. His success grew from there. Over the years, his songs were sung by big names like Bing Crosby and Gene Autry, and he became one of the leading names in the industry. He died in 1940 at the age of 41. (Courtesy of Tufts Library.)

Carroll Bill

Carroll Bill was born in Philadelphia in 1877 but moved to Massachusetts as a child. He lived in Braintree and Boston before moving to Weymouth. A gifted artist, Bill specialized in watercolor paintings and murals. Many of his works depict scenes from towns where he lived—Weymouth and Braintree in particular. Throughout his long career, he was a member of the American Water Color Society of New York, the Boston Art Club, the Guild of Boston Artists, the Weymouth Art Association, and the Boston Society of Water Color Painters, of which he was president for a time. His murals are exceptional and can be seen in many locations, both locally and across the country. He died in 1968 at the age of 90. (Courtesy of Tufts Library.)

CHAPTER THREE: UNFORGETTABLE PEOPLE

Don Kent
Don Kent's weather career began in the third grade in the 1920s when his teacher let him write his weather predictions on the blackboard. From that point on, there was no turning back. He graduated from North Quincy High School in 1935 and quickly went into the business of meteorology, landing a job on WMEX for which he was not paid. During World War II, he served in the Coast Guard as a meteorologist and eventually became a commissioned officer. After the war, he forecasted the weather for WJDA and WBZ Radio. In the 1950s, he became the weatherman on television, finally giving a face to the name. One of the biggest events of his career was the blizzard of 1978, which was, according to Kent, the biggest storm he had ever seen. He did not retire from WBZ until the mid-1980s, having established for himself a reputation of accuracy and skill, setting the standard for weathermen all over. Kent continued to broadcast weather forecasts on the WQRC station of Hyannis and several other local stations until 2003, because weather was simply what he loved to talk about. Weymouth is proud to call Don Kent, the legendary weatherman, one of its own. (Courtesy of Margaret Mathewson Kent.)

Carol Seach Donovan

Carol Seach Donovan was ahead of her time as a creative writer and thinker. It only seemed natural that when the South Shore got its first radio station, WJDA in Quincy, she would write stories to entertain the listeners. However, when she arrived at the station, she found that it was not the writing she would be doing, but the speaking. The station put Carol and her husband William on the air right away, airing a weekday morning show called *Breakfast With Carol and Bill* that featured interviews, jokes, and stories. From there, Carol began her own show called *The Carol Donovan Children's Hour* that she broadcasted from her home. During the show, she told stories to the listeners as if they were right in the room with her and answered letters from fans. This children's show came naturally to Carol, who ran a daycare out of her home for many years. Carol also worked as a secretary in several businesses around town, eventually becoming the executive secretary to the president of Stetson Shoe Co. She died in 2008 at the age of 91. (Courtesy of Stephen King Donovan.)

James D. Asher

James Asher was best known for his role in the broadcasting industry. After graduating from Kansas University School of Business Administration, he founded the South Shore Broadcasting Company in Quincy, which operated WJDA, and the North Shore Broadcasting Corporation in Salem, which operated the WESX station. He served in World War II at the Harvard University Army Training School and the War Department Personnel Center at Fort Devens. He was one of the founders of the Quincy Savings Bank and the South Weymouth Saving Bank and served as director for the Colonial Federal Savings and Loan Association in Wollaston as well as the Milton Bank and Trust Company. A second-degree Mason, Asher was also the director of the YMCA in Quincy, the South Shore Chamber of Commerce, and the Clapp Memorial YMCA. He died in 1973 at the age of 59. (Courtesy of James D Asher Jr.)

CHAPTER THREE: UNFORGETTABLE PEOPLE

Thomas F. Richardson
On January 17, 1950, at about 7:30 pm, nine armed robbers, their faces covered in Halloween masks, made their way into the Brinks garage from the Prince Street side entrance in the North End of Boston. This carefully planned heist went off without a hitch, and within minutes they walked away with $1,218,211.29 in cash and $1,557,183.83 in checks and money orders. In the ensuing months and years, the FBI scoured the surrounding area searching for any evidence that could point to the culprits. After interviewing hundreds of people and following many leads, seven of the men were found. The last two were finally found on May 16, 1956, in an apartment in Dorchester, Massachusetts. One of the final two was none other than Thomas F. Richardson, a Weymouth native. He was sentenced to life in prison for his part in the crime in October 1956 but was later released. Richardson is pictured here with Gerard Murphy, who starred in *The Brinks Job* (the 1978 movie about the infamous crime), and his granddaughter Carol Richardson. (Courtesy of James Richardson.)

Elmer Stennes
Elmer Stennes was a clockmaker who operated his shop at 1 Tick Tock Lane. Most Weymouth people would know that street if they heard it, but not because of the beautiful clocks that Stennes produced. In 1968, Elmer Stennes and his wife had a heated argument, during which he shot and killed her. Stennes was eventually found guilty of manslaughter and sentenced to eight years in prison, but during the trial he continued to make clocks, inscribing them with the initials "O.O.B" (out on bond). While serving his time (he only served about two and a half years) he taught clockmaking. The clocks that were made behind bars were inscribed with the letters "MCIP" (Massachusetts Correctional Institute at Plymouth). Stennes was eventually released from prison and remarried. On October 4, 1975, two men broke into the house at 1 Tick Tock Lane. They killed Stennes and fired shots at his second wife, who rolled under the bed and pretended to be dead. The murderers were never caught. (Courtesy of Carrie Tirrell.)

61

LEGENDARY LOCALS

Frank Lloyd Wright

Famous architect Frank Lloyd Wright was born on June 8, 1867, in Wisconsin. He was the son of Rev. William C. Wright, an itinerant preacher, and schoolteacher Anna Lloyd Jones. Frank was seven years old when his father accepted a job as pastor of the First Baptist Church in Weymouth. He spent many Sunday mornings pumping the bellows of the church organ while his father conducted the service. His father also taught him to play the piano, violin, and cello. His mother took an active interest in Frank's education and began homeschooling him at an early age. While they lived in Weymouth, she purchased a set of educational blocks created by Friedrich Froebel, founder of the first kindergarten. The wooden geometrically shaped blocks could be assembled in many different combinations to form three-dimensional structures. In his autobiography, Frank said that he learned "the geometry of architecture in kindergarten play." Pictured at Lincoln Square, located at the corner of Broad and Washington Streets, a local band pauses in front of Frank Lloyd Wright's boyhood home. (Courtesy of Carrie Tirrell.)

Sally Snowman

Sally Snowman discovered her passion for the ocean as a child at the Wessagusset Yacht Club in North Weymouth. She joined the US Coast Guard Auxiliary in 1976 and was eventually appointed as the civilian keeper of the Boston Light, built in 1716. In this position, she gives tours to students and general visitors on a daily basis, but not without dressing in Colonial garb to highlight the lighthouse's early days. She develops lighthouse educational programs for elementary school children. To qualify for this type of work, Snowman has a doctorate degree in education and teaches a master's program at Curry College. She lives in a house next to the lighthouse during the warm months and stops by to check on the historic building once a month during the winter. (Courtesy of Sally Snowman.)

CHAPTER THREE: UNFORGETTABLE PEOPLE

Hal Holbrook
Hal Holbrook was one of the biggest names in Hollywood throughout the 20th century, but he is not considered a larger-than-life star to folks in Weymouth; here he's just a Weymouth boy. The Holbrook family was one of the original families in Weymouth, dating back to 1635 when Thomas Holbrook bought land in the area. Hal Holbrook grew up in South Weymouth, raised by his grandfather, whom he would always love and respect. He went to a boarding school for some time and then moved on to Culver Military Academy. While a student at Denison University, Hal developed a one-man show called *Mark Twain Tonight*. It eventually became a Broadway show, for which Holbrook won a Tony Award and was nominated for an Emmy Award. He still performs the show today to sold-out crowds. In 2006, Hal went back to his hometown to show his love and support. He performed *Mark Twain Tonight* at Weymouth High School and donated the proceeds to the Weymouth Historical Society to be used as a scholarship fund for Weymouth students entering college. His generous support of Weymouth's history and its students make him a true legendary local. (Courtesy of Jane Holbrook Jewell.)

Stephen Doyle/CarePacks

In 2004, thousands of US troops were serving in Afghanistan, far removed from their families, friends, and homes. Fortunately, there were people in Weymouth who were willing to reach out and make a difference in these soldiers' lives. A group of Weymouth patriots began collecting necessary, everyday items, and sending them over to the troops. With an overwhelmingly positive response, the folks at CarePacks knew their organization would be here to stay. CarePacks became an official nonprofit organization in 2005, and Stephen Doyle stepped up to the plate as president of the board. Under Doyle's direction, CarePacks was sending hundreds of packages overseas to the troops. However, in 2008, the organization was running out of funds, and those involved were afraid that their important mission would have to be aborted. Fortunately, an article ran on the front page of the *Patriot Ledger* announcing that CarePacks needed help. When the paper hit the stands, the support—and the necessary funds—poured in. Residents of Weymouth and the surrounding towns pulled together and got CarePacks back on its feet. Packages were quickly sent overseas and the organization was able to continue doing the generous and vital work that it does. The volunteers of CarePacks and the people of the South Shore showed true pride and patriotism when it was needed the most. In this photograph, Stephen Doyle is shown with students from Sterling Middle School in Quincy, Massachusetts. (Courtesy of Stephen Doyle.)

Alison Cronin

Alison Cronin was just another high school student in Weymouth, competing on the gymnastics team and performing in school plays. However, by the time she graduated in 2005, she had already accomplished more than some accomplish in a lifetime. In 2005, at the age of 18, she competed in the Miss Teen Massachusetts competition. She won first place, which advanced her to the Miss Teen USA competition in New Orleans. In 2008, she was at it again, performing in the Miss Massachusetts competition. She won that, too, and went on to the Miss USA competition in Las Vegas. Not many towns can boast of such an accomplishment; Weymouth has an exceptional representative in Alison Cronin. (Courtesy of Alison Cronin.)

CHAPTER THREE: UNFORGETTABLE PEOPLE

Zoie Burgess

Although she is small, Zoie Burgess has made a big impact on the world. She lost her mother to breast cancer when she was only eight years old and has since dedicated much time and energy into the Susan G. Komen organization. Her hope is to find a cure, and prevent other families from having to go through what her family endured. Zoie drew national attention in 2011 when she stood on the top of Belmont Hill during the Susan G. Komen 3-Day with a sign that said, "My mom died from breast cancer. Keep walking for a cure." Her sign caught the attention of several walkers. One of them, Jim Hilman, a 55-year-old man who had lost his own mother to breast cancer, stopped and took her picture. He posted the picture on the Susan G. Komen 3-Day Facebook page and wore it on his backpack for other 3-Day walks he participated in. As more and more people saw the picture and heard the news of Zoie's dedication and strength, they began to offer support for Zoie and her two sisters who were left in the care of their disabled uncle when their mother died. Before long, people were rallying around the picture, making Zoie a symbol of hope and courage in the fight against breast cancer. She is young, but Zoie Burgess is wise beyond her years and is bound to make a difference in the world. She and her family are truly an inspiration. (Courtesy of Jim Hilman.)

John Collins

John Collins was born in Newfoundland on October 2, 1906. He came to the United States with his father in 1917 and lived in Cambridge, Massachusetts. Collins is a railroad man, having worked there all his life beginning as a brakeman. He moved to Weymouth in 1942 and decided it was home. He became involved in the community as a member of the Wessagusset Lodge of Masons since 1947. Now, at the age of 105, John Collins is the oldest citizen of Weymouth. He drove a car until he was 100 years old and still lives in his own home. Pictured are John Collins (center) with his son Jack Collins Jr. (left) and James Moore, worshipful master of Weymouth United Masonic Lodge (right). (Courtesy of Keith Spain.)

CHAPTER FOUR

Industrialists

Weymouth's long history of growth and development is a testament to its strong economy and dedicated workers. Ever since settlers began arriving from England, the people of the town have been committed to progress and expansion. Throughout the years, there have been dozens of shoe factories in town that employed hundreds of Weymouth's workers, chemical plants that were top-notch in the business, weapon manufacturers that were respected worldwide, and stores that served the families of Weymouth for generations. This chapter is dedicated to industrialists—those Weymouth residents who are not afraid to roll up their sleeves to earn a living and leave their mark on the town and the world.

Reuben Loud
Reuben Loud was born in Weymouth in 1798. His descendants described Reuben and his brothers as being "husky built men, as was their father, with a good team of oxen with which to farm and haul logs." He put his team to good use as a farmer and lumber dealer. He also served the town as a surveyor of wood, lumber, and bark. Reuben died in 1891 at the age of 93. (Courtesy of Don Cormack.)

Loud's Mill

The mill was always an important part of any town, and Weymouth was no exception. Sayle's gristmill, built in the early 1700s on the Mill River, ground the corn for early settlers. In 1836, Reuben Loud (pictured on opposite page) purchased Sayle's mill and built a lumber mill. In 1850, Loud opened a box factory next to the mill. This later became the Weymouth Lumber Company. Pictured is an employee of Loud's Mill loading a wooden box into Herbert Raymond's truck. Raymond owned a local trucking company and frequently did business with Loud's Mill. (Courtesy of Don Cormack.)

Henry Beecher Reed

H.B. Reed was born October 1, 1853, in South Weymouth. A prominent shoe manufacturer, he is said to have been the first man in the United States to sell shoes by displaying samples. Owner and manager of the H.B. Reed Shoe Company, he journeyed to California in 1870 to display samples from his factory. A man of influence in town, he was president of the First National Bank, the Weymouth Fair Association, and the Weymouth Improvement Association, as well as chairman of the school committee. He purchased the Albert Tirrell mansion at the corner of Columbian and Main Streets. His estate would later be purchased to use as the new Weymouth Hospital, which later became South Shore Hospital. Reed, on the right, poses in his carriage at the Weymouth Fairgrounds. (Courtesy of Annie Tirrell.)

Noah Stowell

As early as 1860, Noah Stowell owned a store located at 716 Main Street. According to his advertisement, he was a dealer in dry and fancy goods, tinwares, and more. He carried a full stock of everything and gave prompt attention and square dealing. Noah merged with Wilton A. Loud about 1896 and added groceries with delivery service. Pictured on the left in front of Loud & Stowell is Merton Loud, the brother of Wilton. (Courtesy of Tufts Library.)

James Tirrell
Weymouth and the towns around it became the shoe manufacturing capital of the world in the later years of the 19th century. Practically every corner had a shoe factory. Some were large and employed hundreds of workers like Stetson and M.C. Dizer, but some were simply small shoe shops, located behind a shopkeeper's house where he and his sons would labor day after day. The shoemaking industry in Weymouth dates to the early 19th century, however, and was a result of James Tirrell's ingenuity and hard work. In 1808, Tirrell established the very first shoe shop in South Weymouth where he made boots and shoes to be sold in the city. He would send the boots to Boston in a carrier's saddlebags and hope to make a few cents. At the time, most shoes were made to order by cobblers, but Tirrell's method of producing shoes to be sold on the market must have worked, as it would be the future of the Weymouth shoe businesses. (Courtesy of Carrie Tirrell.)

CHAPTER FOUR: INDUSTRIALISTS

Benjamin Franklin White
The First National Bank of South Weymouth began in 1864 with $150,000 in capital. This began large-scale banking in Weymouth, more like what we see today. Benjamin Franklin White was a businessman who was instrumental in the bank's beginnings. He served as its first president from November 1864 to October 1866 and then worked as the cashier from 1866 until 1880. In 1868, the bank constructed a large building, which also served as a home to the cashier. B.F. White lived in the home that still stands today at 937 Main Street until 1880 when he handed the position over to John H. Stetson. The First National Bank of South Weymouth eventually became the South Weymouth Savings Bank. It operated under that name until 1997, when it merged with two other banks to become South Shore Savings Bank. The bank still serves Weymouth today and has deep roots in Weymouth history that all began with Benjamin Franklin White and his colleagues. (Courtesy of Tufts Library.)

John Smith Fogg

John S. Fogg was born in New Hampshire in 1817 and moved to Weymouth as a teenager. He made a living making shoes, first working for Martin Stetson and then for Martin Vining beginning in 1841. After gaining a few years of experience, he decided he would try his hand at owning a business. He established the John S. Fogg shoe factory in South Weymouth in 1857. The large building still stands in Columbian Square at the corner of Pleasant and Union Streets. In 1878, the company became Fogg, Shaw, Thayer & Co and was very successful. John Fogg truly believed that a community would grow if it had exposure to culture and learning so, with his fortune, he had a large building built for shows and public meetings. The unmistakable Fogg building still stands today at the corner of Columbian and Pleasant Streets, but has been converted to apartments and stores. John Fogg died in 1892, but not before giving back to his community again. In his will, he set aside $50,000 for the building of a public library. His wishes were fulfilled, and the beautiful Fogg Library was completed in 1897. It, too, still stands today, a testament to the growth and progress that came from Fogg's generosity. (Courtesy of Tufts Library.)

John Jacob Loud
A man of many interests and talents, John Jacob Loud was very well known in his hometown of Weymouth. Born in 1844, he graduated from Weymouth High School and then moved on to Harvard University. He became a lawyer and worked as such until his father, the cashier of the Union National Bank, asked him to become his assistant. Loud took the position in 1871. In 1874, his father passed and Loud was appointed as his replacement. He worked as cashier for over 20 years. Loud was a loyal member of the Union Congregational Church and one of the founders of the Weymouth Historical Society. Aside from being a civic leader and cultural contributor, John Jacob Loud was the inventor of the ballpoint pen. The invention was patented on October 30, 1888, and forever changed the art of writing. (Courtesy of Tufts Library.)

M.C. Dizer

Weymouth was home to dozens of shoe factories in the 19th century, and the industry employed the majority of Weymouth's residents. Of all the Weymouth shoe shops and factories, none could compare to the size and scale of the factory of M.C. Dizer and Co. Established in 1843, it rapidly grew and quickly had to change locations. Despite facing several financial hardships, one of which was the loss of Southern trade during the Civil War, Dizer pressed on. His factory eventually became the largest and most productive in town, employing 500 people, standing seven stories high, and covering over 100,000 square feet. It is hard to imagine such a large factory in Weymouth today, but this was the economic lifeline for many people in town. Dizer (pictured on opposite page) was a self-made man who made a fortune by way of hard work and perseverance. He is one of the shining figures of Weymouth's economic past. (Above, courtesy of Debbie Sargent-Sullivan; opposite, courtesy of Weymouth Historical Society.)

CHAPTER FOUR: INDUSTRIALISTS

Zachariah Lovell Bicknell

Zachariah Bicknell (pictured on opposite page) was a larger-than-life figure in 19th century Weymouth. At the age of 17 he began working as a carpenter, but changed careers in 1850 when he became a clerk in Henry Loud's grocery store. After working for Loud for 14 years Bicknell went into business for himself, opening a store to the left of his house (pictured above) that he would operate for 30 years. Besides being a businessman, Bicknell was active in politics. He was elected to the board of selectmen in 1857 and served for 20 years. In 1862, he was a district representative in the Massachusetts legislature. He served on the School Committee, the Board of Assessors, the Board of Auditors, the Appropriation Committee, the Board of Engineers, and the War Board. Bicknell was involved in religious organizations as well. He was the superintendent of the Sunday school at his Methodist church for 24 years and spent his summers on Martha's Vineyard serving as the director of the Martha's Vineyard Camp Meeting Association. Pictured above is the Bicknell Homestead, which was located at the intersection of Pleasant and Commercial Streets. George Washington Toma TV and Appliance now occupies this site. (Courtesy of Don Cormack.)

Nathaniel Bayley
In the 19th century, to live past the age of 80 was quite an accomplishment. In 1903, a man named Nathaniel Bayley passed away at the age of 87. According to his obituary, he was a "quiet unassuming gentleman" who went about his business in a docile way. Bayley was born and raised on Main Street in South Weymouth and lived there until he married Lucy Tirrell in 1840. The couple moved farther down Main Street to Nash's Corner, at the intersection of Middle, West, and Main Streets, where they spent the rest of their lives. It was there that Nathaniel Bayley joined with Leonard Tirrell to operate a shoe shop out of his home called "Tirrell and Bayley Shoe Manufacturers." In later years, he owned a store near his house that he operated until he died. In 1903, he was one of the oldest men in Weymouth and was probably the oldest shopkeeper. Here, Nathaniel is shown in his phaeton in front of his shop. The opposite page shows the Bayley Homestead at the corner of Middle and Main Streets, across the street from the Stetson Shoe building. (Courtesy of Weymouth Historical Society.)

CHAPTER FOUR: INDUSTRIALISTS

Bates Torrey
Born in 1859, Bates Torrey lived in Weymouth for 89 out of the 94 years of his life. He was a writer, poet, and a pioneer in the "touch" typewriting system. One of his key interests was Weymouth history, about which he wrote several books. He served as president of the Weymouth Historical Society for 20 years (ending in 1947) and wrote poems about his hometown that he loved so much. Aside from being a writer and historian, Bates Torrey was a court reporter. Being so adept at using shorthand typewriters, he served in almost every court in Boston. He held that job for more than 44 years. (Courtesy of Donald Cormack.)

Bessie Freeman
Bessie Freeman was a Weymouth resident for 61 years. In 1926, she opened up The Pines, a "private sanitorium," or nursing home, at her home in South Weymouth. She operated the nursing home for 30 years before closing it down in 1956. The Pines is believed to be the first nursing home in Weymouth. Although it is now a private residence, the house still stands at 372 Union Street in South Weymouth and looks almost identical to the way it appeared during the time it was a nursing home. Besides being the proprietor of the business, Freeman was also a member of the Old Colony Club, the Old South Union Church, and the Weymouth Republican Club. She passed away in 1969 at the age of 88. (Courtesy of Weymouth Historical Society.)

Harlow Drug

Every village in Weymouth had its corner store, and Weymouth Landing's was Harlow Drug. It was owned by a hardworking man named Clifton Harlow who sold everything from groceries to banana splits (for 10¢). His store was originally located on the first floor of the Tufts Library at the corner of Washington and Commercial Streets. It eventually moved to its own building across the street on the corner of Washington and Front Streets. Harlow is pictured standing with his son in front of the store. (Courtesy of Jane Lyle.)

Henry Poole

Henry S. Poole was born in Weymouth in 1877. As an adult, he worked as a clerk in Loud and Stowell's store on Main Street in South Weymouth (see page 71). After learning a little bit about the business, he decided to open his own store. In 1920, Poole's Miscellaneous Station opened on the corner of Pleasant and Elm Streets (the current location of Pleasant Brook Apartments), selling gasoline and groceries. Hot dogs went for 22¢ per pound, and popsicles sold at two for 5¢. Poole operated his store until his death in 1957. This 1939 photograph shows Poole on the left, his granddaughter Alice Gardiner on the right, and Alice's husband, Herbert Higgins, in the center. (Courtesy of Michael Anderson.)

Pardo

Salvatore Pardo was a Weymouth cobbler who came to America in 1917. He served in the US Army from October 1917 to June 1919. When he returned to Weymouth, he went to work opening his shoe shop. He had shoe shops at two locations in Weymouth, one being at 198 Washington Street in Lincoln Square and the other at 27 Pleasant Street. In the 1940s, Pardo sold the shop on Pleasant Street to his brother Tony, who operated it as Tony's Spa, a restaurant and bar. It was later sold and is now known as Warren's Place. The photograph above shows Salvy outside his shoe shop at 27 Pleasant Street with a neighborhood child. The image on the opposite page shows him at work inside the shop at 198 Washington Street. (Courtesy of Linda Pardo.)

CHAPTER FOUR: INDUSTRIALISTS

Corbo Brothers

Jim, Fred, and Dorick Corbo were sons of Italian immigrants who believed that hard work and dedication would pay off. Despite having very little education, Fred opened a store in Jackson Square called Corbo Bros. in the 1940s that quickly became the neighborhood hangout for locals. When one thinks of town stores in the 1940s and 1950s, with a soda fountain, friendly service, and a small town feel, the atmosphere of Corbo Bros. is perfectly described. Featuring cigars, magazines, candy, and 16 flavors of Hood ice cream, this store was a place where East Weymouth residents could stop in, get the latest news, have a conversation, and catch up on the town gossip. It was also a practical place where groceries could be purchased for the family. Every morning, fresh eggs and milk were brought to the store from White Bros. Farms in North Quincy. The Corbo brothers operated their successful store for many years. Pictured here from left to right are John ?, Jim Corbo, and Dorick Corbo. (Courtesy of Dorick Corbo.)

CHAPTER FOUR: INDUSTRIALISTS

Elias Beals
Elias Smith Beals, born in 1814, was a prominent figure in 19th-century Weymouth in many ways. He served as selectman, bank director, president of the Village Improvement Society, treasurer of the Third Universalist Church, park commissioner, and representative to the General Court of Massachusetts. As a community leader, Beals was instrumental in abolishing the tolls on the bridges leading from Weymouth to Quincy and Hingham. Additionally, he donated 3.5 acres of his property to the town to be used as a park, aptly named Beals Park. Besides his public service, he also distinguished himself as the owner and operator of Bay State Hammock Factory, which he operated next to his home at 40 Sea Street in North Weymouth (pictured on page 109). The factory building is currently used for the Friends of the Homeless organization. Quite a remarkable resume! (Courtesy of Don Cormack.)

John P. Lovell

John P. Lovell was a 19th-century Weymouth gunsmith who learned his trade with Boston gunsmith A.B. Fairbanks. His highly successful John P. Lovell Arms Company was known throughout the country for its quality products. Lovell was also the president of the Savings Bank of East Weymouth for a time, acting as director at the time of his death, and was a member of the South Shore Masonic Mutual Reserve Association, the Freemasons, and the Odd Fellows. In 1894, Lovell dipped into politics and represented Weymouth's district in the state legislature. He died in July 1897. (Courtesy of Donald Cormack.)

CHAPTER FOUR: INDUSTRIALISTS

Elbridge Nash
Born in 1841, Elbridge Nash was a Civil War veteran and member of the Reynolds Post Grand Army of the Republic. He served as quartermaster of that post from 1870 until the 1920s. In 1875, he opened a drugstore that was located in Columbian Square, South Weymouth. It later moved to the street level of the Fogg Shoe Factory. He delivered products from his store to customers around town. He operated his successful store until late in life. He died in 1926. (Courtesy of Don Cormack.)

LEGENDARY LOCALS

CHAPTER FOUR: INDUSTRIALISTS

John Colasanti

John Colasanti is the embodiment of the American dream. He arrived in Boston from Italy in 1911 at the age of 17, with very little money and hardly any education. He went to work on the Old Colony Railroad, working night and day for $9 per week, half of which he sent back to his family in Italy. He met a young Italian woman named Nattie in 1916, and they married on December 30, 1917. Shortly after their wedding, he was called to war and left to serve his new country in France. When he returned home, he decided he would go into business for himself. His sand and gravel company, the Weymouth Trucking Company, became quite successful after the first year. Soon enough, they owned several trucks and were getting jobs left and right. During the post–World War II years, business boomed as soldiers returned home from war hoping to build a house and start a family. Colasanti's company was instrumental in the building of streets for new neighborhoods, particularly in North Weymouth. All of the streets he built were named for family members, friends, and sometimes employees. Rinaldo Road, Katherine Street, Marion Street, Moreland Road, Donna Street, Peter Street, Judith Street, Carolyn Street, and Steven Street were all his projects and all are still in existence today. In 1955, Colasanti built a bowling alley in East Weymouth because of his own love for the sport, hoping it would be a place for his grandchildren to share his passion. It was later torn down to make way for the Greenbush line of the MBTA commuter rail. He was also active in the Sons of Italy and helped with the planning of the new building in 1972. John Colasanti was a friend to everyone and always offered his help to those who needed it, especially those who wanted to start their own business. He died in 1974 at 80 years old, having done an incredible job improving Weymouth's roads and changing the town in a positive way. Even today, the impact he had on the town of Weymouth is felt by its residents. Colasanti is pictured on the opposite page on his wedding day with his wife, Nattie, and above helping move the Abigail Adams House with John Saltmarsh in the 1940s. (Courtesy of Linda Colasanti Federico.)

Cicchese Family

The Cicchese family brought a lot of joy to the town of Weymouth. Around 1957, Mario Cicchese purchased the rights to the Jasan Theater from Nate Hochberg and renamed it the Victor Theater. Intent on running a family business, he put his brothers Henry and Albert to work right away in the movie theater, training them to operate the projector. They used their new skill to work not only in the Victor Theater but also in the Loring Theater in Hingham and the Apollo Theater in Hull. The family also owned a lunch place down the street that was open late on Friday nights to accommodate moviegoers. Located at 771 Broad Street, it was called Kae's Lunch, named for Mario's wife who operated it. Between these two Cicchese family establishments, Weymouth residents were sure to have a good time. The building that housed the Victor Theater still stands at the corner of Broad and Cottage Streets. Formerly the Odd Fellows building, it was recently sold to Gerald McDonald Jr., who plans to use it as a recording studio. The staff at Kae's Lunch posed for the 1951 Christmas card on the opposite page. From left to right are (first row) Joanie Garafolo, Charlotte ?, Margaret Rizzo, Lila Vaillancourt, and Kae Cicchese; (second row) Mario Cicchese, Edna ?, Anna Cicchese, and Joe Danubio. (Courtesy of William Cicchese.)

CHAPTER FOUR: INDUSTRIALISTS

Bradley Fertilizer

The Bradleys were a prosperous Hingham family in the 19th and early 20th centuries. They owned 40 acres of land in North Weymouth, incorporating much of what is now Weymouthport, Webb Park, Grape Island, Slate Island, and Great Hill. This land was used for the Bradley Fertilizer Company, established in 1863. The company was one of the largest manufacturers of chemical fertilizer in the country. The 1891 Weymouth Town Report indicated that, besides the factory building, there were 37 homes used by factory employees. In the first decade of the 20th century, new homes were constructed to be used by employees, most of them Polish immigrants for which the village got its name. The employees had their own communal garden and school, as well as access to a store, enabling them to live almost exclusively on the peninsula. Although Bradley Fertilizer Company was almost like its own city, the company played a major part in the cultural and economic life of Weymouth. It closed in the 1960s after a century of prosperity and productivity. Bradley employees pictured below are, from left to right, (sitting) Rossman, Griffin, and Scully; (standing) Champion, Bowker, Bradley, Slugg, George, Ward, Kewish, Wood, Breckenridge, Smith, Curran, Arnold, Hickey, Catalano, Parker, Moore, and Bates. (Courtesy of Jo-an Scully Hamilton.)

Stetson Shoe

Stetson Shoe Company was an important part of Weymouth during the late 19th century and first half of the 20th century. It was one of the leading employers of Weymouth residents and produced incredible amounts of shoes every year, distributing them all over the world. Stanley Heald, pictured above, was the president of the company in the 1930s and 1940s, during the heyday of Stetson shoe production. At that time, there were three employees who had worked in the company for over 50 years starting shortly after the company was founded in 1885. Silas Newcomb began working at the Stetson factory in 1887, and Wilton L. Hawes and John F. Corcoran began working there in 1888. All three were dedicated employees who had worked hard to earn an honest living. They and people like them form the core of what it means to be from Weymouth. Below, from left to right, are Wilton Hawes, John Corcoran, and Silas Newcomb. (Courtesy of Carol Seach Donovan.)

Herman Collyer

Herman Collyer was a World War I veteran, the last "call fireman" for Weymouth, and the president of the Weymouth Lions Club. However, Collyer was more than anything a businessman, and a successful one at that. He owned a small store at 9 Sea Street in North Weymouth. During the summer, Collyer and his family moved 1.3 miles down the road to Parnell Street, where he opened a second store. For the entirety of the summer, Collyer would conduct the majority of his business affairs from the Parnell Street store. When he needed supplies, he would send a list to the Sea Street location (which remained open during the summer) and the goods would be brought to the Parnell Street store by wagon. This moving back and forth would seem to be cumbersome, but it must have worked for Herman Collyer; he remained in business for 61 years. On the opposite page, in the upper image, Collyer's Sea Street store can be seen on the left. The lower image shows Parnell Street, where Collyer's second store was located. (Above, courtesy of Velma Collyer; opposite, courtesy of Debbie Sargent-Sullivan.)

CHAPTER FOUR: INDUSTRIALISTS

Thomas' Corner and Post Office, North Weymouth, Mass.

Fort Point, North Weymouth, Mass

Cain's Lobster House

Cain's Lobster House was a South Shore landmark. It stood on the Weymouth side of the Fore River Bridge and was a destination for locals and tourists alike. The restaurant was opened in the 1930s by Capt. Francis J. Cain, who had been lobster fishing for years. At Cain's, it was "Mr. Lobster at his finest." Nothing but the best quality and freshest seafood was served there, and Captain Cain made sure of that. Every morning, Cain and his sons would go 30 to 50 miles out to sea to check on their 500 traps. Hauling back what they caught, they served about 1,000 diners each day. Aside from being a fantastic restaurant, it was also a nightclub and lounge, so it had a little something for everyone. (Courtesy of Debbie Sargent-Sullivan.)

Thomas Pappas

Thomas Pappas and his wife, Demetra, owned a little diner on Bridge Street in North Weymouth. It was originally called United Diner before the name was changed to Pappas' Diner. It sat halfway between the Fore River Shipyard and the Hingham shipyard, on the lot where J&B Auto is today, 291 Bridge Street. Because of its location, it served the workingmen of Weymouth as a place to stop and get a quick bite to eat, guaranteed to be served with a smile. During World War II, the men stationed at both shipyards were regulars at the joint. The menu had everything from a hot chicken sandwich served with mashed potatoes for 75¢ to a cup of clam chowder for 35¢. It was everything that one could want out of a 1950s diner. Thomas and Demetra Pappas operated their family business for years. It sold in 1955 and was moved that year. (Courtesy of William Pappas.)

LEGENDARY LOCALS

Allen Emery

Allen Comstock Emery Jr. (pictured on opposite page) was known to most Weymouth residents as the man who owned the Mount Vernon replica mansion in Weymouth Heights. But he was also a man who was well liked, loyal, and friendly. Born in 1919 in Weymouth and a 1937 graduate of Weymouth High School, Emery attended Wheaton College in Illinois for a year before he returned home to learn his father's Boston-based wool business, Studley and Emery. He worked for the company for a few years until the attack on Pearl Harbor. In 1941, he joined the US Coast Guard and served on the USS *Allentown*, surviving a kamikaze raid. Aside from being a good businessman, Emery was also a faithful Christian. He and Marian, whom he married in 1942, were leaders of a youth bible group that they often hosted at their home. Emery also served as president of the Evangelistic Association of New England and as a life deacon at Park Street Church in Boston. He was known as being a great storyteller, having lived through fascinating experiences throughout his life. He died on October 26, 2010, leaving three children, six grandchildren, and six great-grandchildren. (Courtesy of James Clarke.)

The Merchants Association

The Merchants Association was a group of business owners from Jackson Square formed to promote economic development. Pictured above in 1952, the merchants hand the key of success to their newest member. From left to right are Joseph Striano, Wally McIsaac, Marion Baker, George Diersch, Benjamin DiBona, and Dr. Albert Aisenstadt. Although there is no longer a Herring Run Merchants Association, several of them are still in business. Below, in front of Jackson Square Paint, Joe Striano Jr. and Larry DiBona of Justice Hardware hold the original Herring Run Merchants key of success. (Above, courtesy of Joseph Striano Jr.; below, courtesy of Debbie Sargent-Sullivan.)

Fitzgerald's Fabric Store

When a woman who lived on the South Shore needed sewing supplies, she knew to go to Fitzgerald's Mill End Store. Founded by Susan Clarke Fitzgerald, it was located on Washington Street in Weymouth and had everything a well-equipped seamstress would need. Their fabric list was quite extensive—chambray went for 69¢ a yard, and dimity for 49¢ a yard. The Fitzgerald family lived on the premises and made the experience of shopping at their store unique. There was a playground outside the store with houses and swings where customers' children could play while their mothers were shopping, and farm animals roamed the grounds. Fitzgerald's Mill End Store is no longer in business, but the experience that Weymouth residents found when they shopped there is certainly well remembered. (Courtesy of Regina Fitzgerald.)

Welcome Farm

In 1996, South Weymouth changed forever. The sight of the purple spotted cow that had become so familiar to residents was now gone. The cow sat atop a little store called Welcome Farm, which was owned and operated by Jim and Joan Dwyer. Welcome Farm was an ice cream shop that the Dwyers had created out of their home, and it served handmade ice cream in several flavors. The Dwyer family worked diligently since the day it opened in order to make every customer's visit a truly special experience. By the time the Dwyers decided to close up shop, their ice cream had become widely popular all around the south shore and beyond. The Dwyers' commitment to making their business thrive is an example of the American dream that seems to be fading with time. They worked hard and made their shop a legend. It closed in 1996 after 35 years of business. (Courtesy of Edgar Dawes.)

Al Dewey

On Bridge Street in North Weymouth sat a little store called Alemian's Café that was built in 1925. It started as a variety store in the front and a bait shop in the back and was operated as such until 1934. That year, the store was issued the first beer and wine license in Weymouth, and it began to serve beer to people at a stand-up-only bar. On Sundays, the bar had to be closed to abide by the law, but you could still be served a beer as long as you were sitting in a booth. The bar was eventually purchased by Richard Alan "Al" Dewey, a lieutenant in the Weymouth Fire Department, who changed the name to The Sandtrap. The place was later sold to Dewey's son-in-law John Milley, and then again to another firefighter, John Sullivan, who bought it in 1997. The bar that was built in 1925 and made popular as The Sandtrap by Al Dewey still stands today and has been a popular hangout for Weymouth residents for generations. (Courtesy of Al Dewey's Sandtrap.)

McDonald Family
The McDonald family began their funeral business in 1912. Joseph McDonald and his wife, Rosella, opened their first funeral home out of their house on Broad Street in Weymouth. Their oldest son, George, entered the business as well, and decided to expand after serving in World War II. In 1949, the family opened a second location on Charles Street, the former estate of the Clapp Shoe Factory. George's wife, Mildred, worked as the funeral director. Ten years later, the company expanded when they added a location at 809 Main Street in South Weymouth. George Sr.'s sons Joe, Bob, Dick, and George were all involved in the family business. In the 1980s, the company was experiencing incredible success, so they opened a third location at 40 Sea Street in North Weymouth (the former E.S. Beals and Mathewson Estate, pictured on opposite page; also see page 89). In 2011, the McDonald brothers joined their business with Keohane Funeral Service. Pictured above from left to right are McDonald brothers Dick, Bob, Joe, and George Jr. (Courtesy of Richard McDonald.)

CHAPTER FOUR: INDUSTRIALISTS

Hajjar's

The Hajjar family have been business owners in Weymouth for generations. Their first business was the Lakeview Ice Company, pictured above. In this business, men using six-foot-long saws would harvest ice out of Whitman's Pond. From there they delivered the ice to Nantasket Beach and various other places. In 1949, the Hajjar family opened a bowling alley at 969 Washington Street in Weymouth called Lakeview Bowling Alley. From 1950 to 1953, the alley (pictured opposite above) was used for Sunday services while St. Albert the Great Church was being constructed. In 1956, the family converted the bowling alley into a roller skating rink. Tillie Hajjar (pictured opposite below) is best remembered for working the snack bar and helping patrons. When interest in rollerskating began to wane, the family decided to make the rink into a fitness club, serving various food dishes where the snack bar once operated. Finding great success serving Tillie's Lebanese dishes, the Hajjar family transformed the business again, this time into a full service restaurant. Hajjar's Bar and Grille is still operating today with Tillie active in business operations. (Above, courtesy of Zako and Phil Hajjar; opposite, courtesy of Lisa Farrell Corey.)

CHAPTER FOUR: INDUSTRIALISTS

Bill "Billy Budd" Peterson
Bill Peterson is not from Weymouth, but he is known in Weymouth for his outgoing personality and his delicious sandwiches. He was the owner of Billy Budd's Restaurant and Pub on Bridge Street in North Weymouth, and the hangout had a great reputation. But Bill Peterson has an alter ego. For years, he has impersonated the comedian Rodney Dangerfield so accurately that many call him Rodney. He has made quite a name for himself over the years, having performed as Dangerfield locally and as far away as Puerto Rico. Although his sub shop has closed, his impersonation of Rodney Dangerfield has earned him a place on the list of Weymouth's best-known people. (Courtesy of William Peterson.)

CHAPTER FIVE

Athletes

Athletic pursuits, although dating back to ancient history, have not always been something that everyday people participated in. Typically, sports were reserved for the leisured classes and those who did not have to work every day. However, in the late 19th century, people began to look at organized sports as a way to stay fit and experience friendly competition, as well as a form of entertainment for the spectator. Weymouth began its tradition of athletic organization in the mid-19th century, offering competitive baseball and lacrosse, and continued in the 20th century, expanding the types and degrees of competitive activities offered. Today, the town's school teams and athletic organizations are some of the best around, and Weymouth has sent athletes to the Olympics and to professional sports teams on several occasions. The following chapter focuses on the athletes and athletic teams of Weymouth.

Weymouth Athletes

Dating back to the 1860s when baseball was popular in town, Weymouth's athletes have loved to compete. Pictured above are the North Weymouth Athletic Club football champions in 1900, including (first row) William Gunville, Stanley Torrey, Charles Sheehy, Michael Lane, Joseph Lane, Matthew Sweeney, James Scully, Michael Sweeney, and Wesley Sampson; (second row) Leis French, No. 4, ? Sheehy, unidentified, and Honey Jenkins Right. The side onlookers are James and John Condon. Below are members of the 1906 Weymouth High School basketball team, including (first row) Dan Reidy, Sydney Beane, ? Ford, Button Raymond, and Louis Carter; (second row, standing) Brownie Wilder, ? Hennesy, and Fred Nolan. (Above, courtesy of George Lane; below, courtesy of Sydney Beane.)

"Dad White's" Lacrosse Team

On August 29, 1885, the Independent Lacrosse team of Boston and the Weymouths, sponsored by Thomas Irving White, played a championship game in Brockton. They gave an excellent exhibition before several thousand people on the fairgrounds. The score at the end of the first half hour was 5-0 in favor of the Independents. In the next half hour the defense and the home men changed positions and the Weymouths made six goals to win the game. Pictured from left to right are (first row) Eaton Reed (attack) and Bert Bass; (second row) Alston Shaw, Edmond Walsh (home), Harry Poole (point), Walter Bates (attack), Allen Holbrook (center), Thomas Irving White (counterpoint), Louie Moore (attack), Thomas Kelley (defense), Josiah Reed (home), Charles Richards (goal), and Charles Thomas. (Courtesy of Weymouth Historical Society.)

Dan Howley

Born in 1881, Dan Howley began his baseball days in Weymouth playing both in school and for the Clapp Memorial team. He was involved in baseball, both as a player and as a coach, including his time as a pitching coach for the Red Sox in 1918. He moved all over the country, from Indianapolis to New York, Cleveland to Portland, Philadelphia to Montreal, Toronto to Hartford, and back to Boston, always following where baseball led him. He played catcher in several minor and major league teams at the beginning of his career and then went on to coaching. In 1926, he was appointed as the new manager of the St. Louis Browns. Weymouth could not have been prouder of its legendary baseball star. The town declared June 11, 1927, a legal holiday: Dan Howley Day. Dan Howley is pictured to the right and below at Fenway Park with Civil War veterans and Stetson's "Snappy Tie Girls." (Courtesy of Carol Seach Donovan.)

CHAPTER FIVE: ATHLETES

ALICE MELVILLE IRENE WHITE AINA JERPI THOMAS CUTHBERT NORA GAYDON MARJORIE THOMAS GRACE LOEFFLER

"They've Got to be Stetson to be Snappy"
JANUARY 14, 1925

Stetson Shoe Snappy Tie Girls
The advertisement read, "This is one of the happy groups of Stetson models to be seen in the Stetson Shoe Snappy Revue, to be presented three times in the Main Ballroom of the Copley Plaza Hotel. Interwoven with a demonstration of latest styles in shoes, is a tuneful show." Sponsored by the Stetson Shoe Company, the Snappy Tie Girls performed musical shows while promoting current shoe fashions. Pictured in January 1925 from left to right are performers Alice Melville, Irene White, Aina Jerpi, Thomas Cuthbert, Nora Gaydon, Marjorie Thomas, and Grace Loeffler. Note the insignia on the dresses. Stetson Shoe changed their crossed S logo during World War II because of its resemblance to a swastika. (Courtesy of Carol Seach Donovan.)

117

Anna Garrity Erwin

Anna Garrity Erwin was a dancer all her life. In 1926, she opened the Anna Garrity School of Dancing, which she operated until she retired in 1979. She was a member of the executive board of the Dance Teacher's Club of Boston, Dance Educators of America, and Dance Masters of America. Many of today's dance instructors learned their skills from her, so she continues to impact the dance community in the 21st century. She passed away in 1980 at the age of 69. (Courtesy of Rev. William R. Campbell, S.J.)

Harry Arlanson

When Harry Arlanson arrived in Weymouth to coach the Weymouth High School football team in 1935, the team needed work, to say the least. During the three years before he arrived, they had won only three games. Harry quickly went to work, making the Weymouth Maroons into champions. The year after Arlanson arrived, they were undefeated. The highlight of his time in Weymouth was in 1950 when the team went to Jacksonville, Florida, to compete in the Gator Bowl. They defeated the Landon High team 34-18 and came home as heroes. In the 17 years that Arlanson coached the Weymouth High football team, he had eight teams that were undefeated; his teams won a total of 133 games and lost only 19. Although Harry Arlanson left Weymouth in 1954 to coach the Tufts University team, he will always be a legend to the team that he turned around, and to the town he changed forever. (Courtesy of Carl Arlanson.)

LEGENDARY LOCALS

CHAPTER FIVE: ATHLETES

The 1950 Gator Bowl
From left to right are Weymouth High Gator Bowl football team members (first row) Normie Wright, Bob Duke, Dick Pearce, Bill Moore, Dick Piccuitto, Bob Nelson, Jim Belcher, Bill Sprague, John Trueman, Warren Fardig, and Stu Hemingway; (second row) Pinky Porter, Burleigh Roberts, Glenn Allen, Bob Savola, Jim Kane, Jack Coveney, Jim Kilburn, Dick Alemian, Dorick Mauro, and coach Harry Arlanson. (Courtesy of Carl Arlanson.)

Kathy Corrigan

Kathy Corrigan's passion for gymnastics began in high school. Since Weymouth High School did not have an official gymnastics team in the 1960s, she went out for cheerleading and became a captain. After competing in tumbling competitions on the side, Kathy decided to pursue her career in gymnastics when she graduated from high school. She entered Springfield College and quickly became a serious gymnast. In 1963, she went to São Paulo, Brazil, and competed in the Pan American games, where she won four medals. The next year, she competed on the US women's Olympic gymnastics team in Tokyo, Japan. From 1966 to 1968, she served as the gymnastics consultant to the President's Council on Physical Fitness and Sports. In 1968, Corrigan opened up her own school of gymnastics. Her business is still thriving today. (Courtesy of Kathy Corrigan.)

CHAPTER FIVE: ATHLETES

Mary Jackson

Mary "Mae" Jackson is a force to be reckoned with. That is not something that is usually said about a 97-year-old, but in this case it is certainly true. She taught herself how to swim as a child and has been swimming her entire adult life in order to stay active. So, when her granddaughter saw that the National Senior Games have qualifying matches in each state, she knew that Mae should be a contender. When she competed at the state level in Springfield in 2008, she came in first in both of her races, which qualified her for the games in 2009. Mae Jackson went to the 2009 National Senior Games in California and came home with three gold medals in swimming. Winning three Olympic gold medals is something that many athletes only dream of, but for Mae Jackson it was just another day in the pool. (Courtesy of Mary Jackson.)

123

Tim Sweeney
Tim Sweeney's hockey career began in Weymouth. He was a varsity starter for Weymouth North High School, where he became an all-time leading scorer. After graduating from high school, Sweeney played for Boston College from 1985 to 1989. After college, his career took off. He was drafted by the Calgary Flames in 1990 and played on the team for two years. From there, he went home to Massachusetts and played for the Boston Bruins for a year before heading out to the Anaheim Mighty Ducks for two years. In 1995, Sweeney headed back to the Boston Bruins and played with them until 1997. He ended his career with the New York Rangers before retiring from hockey in 1998. Sweeney was not only an NHL player; in 1992, he played for the US men's Olympic hockey team in Méribel, France. A great hockey player from a great town! (Courtesy of Tim Sweeney.)

George Player
George Player is a Weymouth icon as a baseball coach, baseball player, and teacher. His baseball career began in 1952 when he signed on with the Boston Braves. After that, he played for the Quebec City Braves, the Nova Scotia Summer League, Cedar Rapids, Wellsville New York, Detroit Tigers, and Cape Cod league—to name a few. He began teaching Spanish and French at Weymouth High School in 1962 and began coaching baseball the same year. His 36 years teaching at Weymouth High School include 18 years of coaching the baseball team. The team did remarkably well the whole time he was coach, and every student who had him as a teacher loved him. Player retired from teaching in 1997, but his students and team members will always remember and appreciate the positive impact he had on Weymouth High School. (Courtesy of George H. Player.)

INDEX

Adams, Abigail, 52
Adlington, Francis, 54
Aisenstadt, Dr. Albert, 104
Alemian, Dick, 120
Allen, Glenn, 120
Arlanson, Coach Harry, 120
Arlanson, Harry, 119
Arnold, 96
Asher, James D., 60
Baker, Marion, 104
Bass, Bert, 115
Bates, 96
Bates, Joshua, 53
Bates, Walter, 115
Bates, Walter L., 25
Bayley, Fred C., 25
Bayley, Nathaniel, 80
Beals, Elias, 89
Beane, Sydney, 114
Bicknell, Zachariah Lovell, 78, 79
Bill, Carroll, 58
Blanchard, Caroline, 27
Blanchard, John S.C., 25
Blanchard, Nathaniel, 27
Blanchard, Susan Hunt, 27
Bolles, Charles H., 25
Bowker, 96
Bradley, 96
Bradley Fertilizer, 96
Breckenridge, 96
British consul, 25
Brown, Prescott, 26
Burgess, Zoie, 65
Cain, Capt. Francis, 100
Campbell, Donald, 36
canoe boys, 36
Cappellini, Michelle, 46
Carter, Louis, 114
Carven, Gerry, 40
Catalano, 96
Champion, 96
Chapman, Maria Weston, 53
Charlotte, ? 95
Cicchese, Anna, 95
Cicchese family, 94, 95

Cicchese, Kay, 95
Cicchese, Mario, 95
Cicchese, Roger, 35
Chapman, Henry, 53
Chapman, Maria Weston, 53
Clapp, Davis Bates, 56
Clapp, Edwin, 56
Clapp, Mrs. W.H., 25
Clapp, William H., 25
Colasanti, John, 92
Colasanti, Nattie, 92
Collins, John, 66
Collins, John Jr., 66
Collyer, Herman, 98, 99
Colnaghi, Sir Dominick, 25
Condon, James and John, 114
Connelly, Paul, 20
Connor, John, 16
Cope, Bill, 40
Cope, Paul, 40
Corbo, Dorick, 88
Corbo, Jim, 88
Corbo, Fred, 88
Corcoran, John, 97
Cormack, Don and Eleanor, 36
Corrigan, Kathy, 122
Cowing, Francis H., 25
Cronin, Alison, 64
Curran, 96
Curtin, Jake, 40
Cuthbert, Thomas, 117
Dad White's lacrosse team, 115
Danubio, Joe, 95
Dewey, Al, 107
DiBona, Benjamin, 104
Diersch, George, 104
DiSessa, Vincent, 45
Dizer, M.C., 72, 76
Donovan, Carol Seach, 60
Doyle, Daniel, 36
Doyle, Stephen, 60
Dumont, Eileen Ellis, 46
Duval, Don, 16
Driscoll, Alma, 43
Edna, ?, 95
Emery, Allen, 102, 103

Erwin, Anna Garrity, 118
Evans, Cecil, 34
Fifield, Hannah, 54
Fitzgerald, Susan Clarke, 105
Fogg, John Smith, 74
Foley, Jim, 42
Ford, ?, 114
Frazier, Robert, 22
Freeman, Bessie, 83
French, Leis, 114
Fryer, Franklin, 42
Garafolo, Joanie, 95
Gardiner, Alice, 85
Gardner, James E., 38
Garrison, William Lloyd, 53, 54
Garvey, Paul, 36
Gaydon, Nora, 117
Geaghan, Peter, 22
George, 96
Ghiorse, John, 57
Gunville, William, 114
Hallstram, Charles, 25
Hajjar's, 110, 111
Harlow Drug, 84
Hart, Jack, 42
Hawes, Martin E., 25
Hawes, Wilton, 97
Hebert, V. Lesley, 33
Heffernan, Walter, 18
Hennesy, ?, 114
Herring Run Merchants, 104
Hickey, 96
Higgins, Herbert, 85
Hill, Billy, 58
Hilman, Jim, 65
Holbrook, Allen, 115
Holbrook, Hal, 63
Holbrook, Jane, 63
Howe, Appleton, 23
Howley, Dan, 116
Hunt, Butch, 14
Hunt, Edmund Soper, 55
Hunt, Edward Aubrey, 55
Hunt, John Quincy, 14, 16, 17
Hunt, Robert, 41
Hyde, Reverend, 30

Jackson, Mary, 123
Janik, Jonathan, 19
Jenkins, Honey, 114
Jerpi, Aina, 117
Jewell, Jane Holbrook, 40
Johnson, Barbara, 47
Kay, Susan, 48
Kelley, Thomas, 115
Kent, Don, 59
Kewish, 96
Lane, George, 38
Lane, Joseph, 114
Lane, Michael, 114
Loeffler, Catherine Tucker, 35
Loeffler, Grace, 35, 117
Loeffler, Ruth, 35
Lord, George Stinson, 37
Loud, Annie F., 25
Loud, John Jacob, 75
Loud, John J., 25
Loud, Reuben, 68, 69
Loud, Wilton, 71
Lovell, John P., 90
Mathewson family, 39
Martinson, Terry, 39
McDonald family, 108, 109
McDonald, Gerald Jr., 94
McDonald, Richard, 36
McGovern, Helen, 44
McIsaac, Wally, 104
Melville, Alice, 117
Merritt, Susan Torrey, 50
Milley, John, 107
Moore, 96
Moore, James, 66
Moore, Louie, 115
Murphy, Gerard, 61
museum tour guides, 46
Myrick, Charles, 25
Nash, Elbridge, 91
NAS women security guards, 18
Newcomb, Silas, 97
Nolan, Fred, 114
North Weymouth Athletic Club, 114
O'Connor, Bob, 22
Pappas, Demetra, 101
Pappas, Thomas, 101
Paterson, Hope, 46
Pardo, Salvatore, 86, 87
Parker, 96

Peterson, Bill "Billy Budd," 112
Player, George, 125
Poole, Harry, 115
Poole, Henry, 85
Pratt, Franklin, 32
Pratt, Maria L., 25
Procter, Kyle, 20
Quinn, Colonel Mary C., 21
Raymond, Button, 114
Raymond, Herbert, 69
Reed, Eaton, 115
Reed, Henry Beecher, 70
Reed, Josiah, 115
Reed, Quincy L., 25
Reed, William H., 25
Reidy, Dan, 114
Richards, Charles, 115
Richardson, Carol, 61
Richardson, Thomas F., 61
Riley, William P., 20
Rizzo, Margaret, 95
Rhines, John B., 25
Saltmarsh, John, 92
Sampson, Wesley, 114
Santosuosso, Steve, 22
Scully, James, 114
Seach, William, 12
Shaw, Alston, 115
Sheehy, ?, 114
Sheehy, Charles, 114
Slugg, 96
Snowman, Sally, 62
Smith, 96
Starrett, Earl, 16
Stennes, Elmer, 61
Stetson, John H, 73
Stetson Shoes (Heald, Hawes, Corcoran Newcomb), 97
Stetson Shoe Snappy Tie Girls, 117
Stowell, Noah, 71
Striano, Joseph, 104
Sullivan, John, 107
Sweeney, Matthew, 114
Sweeney, Tim, 124
Thomas, Charles, 115
Thomas, Marjorie, 117
Tirrell, Albert, 70
Tirrell, James, 72
Tirrell, Lucy, 80, 81
Torrey, Bates, 82

Torrey, Pvt. William, 11
Torrey, Stanley, 114
Torrey, Zerah Watkins, 10
Tufts, Susan, 30
Union Wharf Ice Company, 25
Vaillancourt, Lila, 95
Ventre, George/Stetson Band, 28
Walsh, Edmond, 115
Ward, 96
Webb, Fred, 16
Webb, Rebekah, 25
Welcome Farm, 106
Weston, Thomas, 2
Weymouth Historical Society, 24, 25
White, Benjamin Franklin, 73
White, Irene, 117
White, T. Irving, 115
Wilder, Brownie, 114
Wood, 96
Wright, Anna Lloyd, 62
Wright, Frank Lloyd, 62
Wright, Rev. William C., 62

LEGENDARY LOCALS

AN IMPRINT OF ARCADIA PUBLISHING

Find more books like this at
www.legendarylocals.com

Discover more local and regional history books at
www.arcadiapublishing.com

Consistent with our mission to preserve history on a local level, this book was printed in South Carolina on American-made paper and manufactured entirely in the United States. Products carrying the accredited Forest Stewardship Council (FSC) label are printed on 100 percent FSC-certified paper.

MADE IN THE USA